# OLYMPIC VALLEY

## &

# ALPINE MEADOWS

*Tales from Two Valleys*

## EDDY STARR ANCINAS

WINNER OF INTERNATIONAL SKI HISTORY ASSOCIATION
SKADE AWARD FOR "OUTSTANDING BOOK ON REGIONAL SKI HISTORY"

THE
History
PRESS

Published by The History Press
An imprint of Arcadia Publishing
Charleston, SC
www.historypress.net

*Front cover, top*: Amie Engerbretson makes first tracks in Alpine Bowl. High Traverse and Lake Tahoe in background. *Photograph by Tom Zikas; front cover, bottom*: Wayne and Sandy Poulsen, 1940, in Squaw Valley Meadow with friends, contemplating how and where to build their ski area. *Courtesy of the Poulsen family.*
*Back cover, inset*: Squaw Alpine Snow Safety Team in Alpine. *Photograph by Ben Arnst.*

\*\*\*

For a brief explanation of the ski area's name change to Palisades Tahoe in 2021, please see the epilogue.

AUTHOR DISCLAIMER: All references in this book to the term *squaw* are purely for historical context and are not meant to be offensive or disrespectful in any way.

First published 2025

Originally published 2013 as *Squaw Valley and Alpine Meadows* (9781467144056)

Manufactured in the United States

ISBN 9781467159586

Library of Congress Control Number: 2024951901

*I took the past two nights to read Eddy's book. I think it is an important, delightful read. She has insights I haven't found in some of the other books I've read about skiing in this region…and I have read almost all the books in her bibliography. Very well done and very enjoyable.*
*—Ray Garland, March 24, 2013*

*Eddy, you write beautifully. I find your book a real page turner, and I am learning a lot I didn't know about my old buddy, John Reily. Well done.*
*—Steve Brandt, March 2013, former president,*
*League to Save Lake Tahoe, writer, professor*

*Skade Award: Presented for an outstanding work on regional ski history.*
*—2014 International Ski History Association*

*To Osvaldo—for getting on the chairlift with me.*

# CONTENTS

# FOREWORD

Growing up in Squaw Valley was just about as good as it gets for a kid. For starters, the mountain provided an ideal playground, with all the terrain and snow conditions you needed to become a top-level skier in whatever discipline suited you. When we weren't training on Olympic runs, we were launching off cornices, cliffs and jumps or tackling endless moguls on the steeps of West Face. Beyond the mountain itself, Squaw was home to an international smorgasbord of talent—daring, skilled and enthusiastic athletes and coaches who inspired and encouraged successive generations of skiers. Many of them had stayed on after the 1960 Olympics, and by the '70s a vibrant ecosystem breeding world-class athletes was in full swing. Even starting out as weekend warriors from the Bay Area, our family was wrapped snugly into that culture. As young ski racers, we were guided and pushed by French, Swiss, Austrian, Japanese, Argentinian and American coaches and welcomed by the local athletes, with whom we strove to keep up. When I went from the Mighty Mite Program to the U.S. Ski Team and to the Olympics, I followed a well-worn path.

Back then, the mountain was home to not one, but four different ski clubs, each of which operated independently. As with the privately owned businesses at the base area, these clubs operated at the behest of a single owner, Alex Cushing. On the one hand, it created a wacky dynamic of ongoing turmoil and consternation, one that defied the model of corporate resort development. On the other hand, the free market approach where nobody reigned and everybody belonged supported unlikely friendships and a dynamic feeling of equal opportunity.

Meanwhile, Alpine Meadows, a snowball's roll from Squaw, had an entirely different—and entirely peaceful—feel. The unique identities of each valley endure to this day. Where Squaw's vibe is rock and roll, Alpine's is easy listening. "Squallywood" popularized and celebrated extreme skiing culture, where skiers earn their stripes by skiing exposed lines in view of the adoring masses. Alpine cultivated its reputation as a quieter, family mountain, where skiers routinely hike for fresh turns and are less likely to seek or find notoriety for their exploits. Even to first-time visitors, this distinction is immediately and visually clear. From the first bend in the access road, Squaw Valley unfolds dramatically—its alluring meadow backed by five peaks issuing both an invitation and a challenge. Just around the corner on Highway 89, Alpine Meadows is nestled in the privacy of its own valley. It only reveals its full beauty when you venture in for a deeper look and explore its folds and trees for the best terrain.

In both cases, these first impressions aptly represent what each area's original visionaries intended.

Alex Cushing's audacious bid for the 1960 Olympics did indeed put an unknown area on the map and entice an international population of skiers to build it, grow it and shape it. When John Reily first gazed at Alpine Meadows from horseback in 1957, he envisioned a quieter alternative, the family-friendly paradise Alpine would become. Through multiple owners at Alpine Meadows and beyond the Cushing era at Squaw, through the vagaries of weather, finances, growth, natural and economic disasters and changing technology, the resorts and their communities retain their characters.

In the *Tales from Two Valleys*, Eddy Ancinas explores and connects the history of both valleys, explaining how the culture at each area evolved, as well as the people, relationships and pivotal events that shaped the evolution. Throughout, the meticulously researched and entertainingly told history depicts the enduring ethos of these two mountains and how they complement and balance each other. Of course, people are at the heart of the story: the early visionaries, whose sensibilities may have differed, were driven by a shared awe for this place and the community of fun-loving, strong-bodied and strong-willed mountain people that coalesced around it. From Wayne Poulsen's first glimpse of Squaw Valley in 1931 to the inevitable merger of Squaw Valley and Alpine Meadows in 2012, the very stubbornness—some would say dysfunction—that has thwarted attempts to make the areas "destination resorts" has also made them precious bastions of independence. Both have resisted the corporate homogenization now so prevalent in ski resorts.

There is, perhaps, nobody better qualified to tell this tale. Eddy herself, as a young volunteer at the Olympics, found one of the many treasures brought by the 1960 Olympics in her husband, Osvaldo. His impact on the Lake Tahoe Ski Club spawned scores of talented skiers, and their store at the base of Alpine Meadows, Casa Andina, was a landmark for my generation.

It was a privilege to grow up in such an extraordinary place, and it is a pleasure to now know the full story behind it.

—Edie Thys Morgan

*Edie Thys Morgan is a freelance writer, author and mother of two living in Etna, New Hampshire. After eight years on the U.S. Ski Team, competing in two Olympics and three World Championships, she lives by her late father's belief: "Once you get your boots on and go out there, everything will be all right."*

# ACKNOWLEDGEMENTS

In writing this book, I owe a great debt to Wayne Poulsen, John McClintic Reily and Alex Cushing—all of whom provided skiers with a great mountain and me with a great story.

If John Milner Reily hadn't suggested to me that someone should write a history of Alpine Meadows and his father's involvement, I might not have embarked on this adventure. And if Mark McLaughlin hadn't encouraged me not to "ignore the elephant next door," I might not have faced the challenge of writing a history of Squaw Valley. I also thank Mark for sending me to The History Press, where Aubrie Koenig has led me through the writing and publishing process with patient care, wisdom and enthusiasm.

I am grateful to Hans Burkhart for sharing with me his personal archive of articles and letters, which reveal much about the ski area he helped develop and the man behind it. Others who have entertained and informed me with tales of Squaw Valley are: Sue Bennet, Henrik Bull, Barry Bunshoft, Phil Carville, Ernst Hager, Tom Kelly, Joan Klaussen, Bill Newsom, Bill and Norma Parsons, Eric Poulsen, John Fell Stevenson and David Tucker. Peter Bansen's detailed memoir of Blyth Arena helped me tell a story unbeknownst to many.

I owe much to Werner Schuster for his chronicle of events at Alpine and to Fern Elufson for answering questions and filling in the blanks, as did Howard Carnell, Barbara Northrop and Bill Evers. Steve Brandt, Sue McCafferty and John Lloyd and his daughter Cheryl Scheer all helped me understand John Reily's venture into Twin Peaks. Troy and Susan Caldwell gave generously of their time and information on their adventure, which is worth a book of its own.

No one can write a book of ski history without the museums and their curators. Thank you, Bill Clark, for scanning, sorting, searching and making as much information available as the Western SkiSport Museum could provide. Hopefully someday, Sierra ski and Olympic history will be displayed in a modern museum near Squaw Valley. Carol Van Etten supplied piles of newspaper clippings and information from her Tahoe City History Research project.

Although absent from their favorite haunts, Bob "Fro" Frolich and Jane Feidler's stories keep history alive. Peter Klaussen, also absent now, straddled both mountains. His memoir and recollections of early explorations in both areas and his deep appreciation for mountains, snow and all things Alpine made this a better place and a better book.

If a photograph is worth a thousand words, I owe a million thanks to Jennifer Austin, who allowed me to use her father, Don Wolter's, excellent black-and-white photos of Alpine in its early years. She opened her home, her attic and many boxes of her dad's photos, and with the help of her brother Grant's scanning, readers will appreciate the quality of his photography. Bill Briner, always generous in sharing his Olympic photos, made them available to me with help from Jim Kass at Barifot in Tahoe City. Nathan Kendall at Squaw Valley Ski Corp. and Eric Poulsen spent hours searching and copying. Thanks also to Tom Lippert, Hank de Vre and Tom Zikas for some of your best shots. The hardest part was putting it all together. I couldn't have done it without my in-house photo editor and beloved son Marcos.

My husband, Osvaldo, cooked, cleaned and protected my territory, allowing me to accomplish a goal we both desired. Children and grandchildren have been constant supporters.

Lastly, thank you, Oakley Hall, mentor and muse to all Squaw Valley writers.

# INTRODUCTION

In the rugged High Sierra at the north end of Lake Tahoe, California, two adjacent valleys lie protected by high peaks to the west and separated by a massive ridge. The story of how these two remote valleys became two (now one) of the best-known ski areas in North America begins with their discoveries by two visionaries: Wayne Poulsen, a young ski competitor from Reno who first saw the potential in Squaw Valley while fishing there as a boy in 1931, and John Reily, a Los Angeles businessman who came to Squaw Valley in 1955 and saw from the top of the KT-22 ski lift a pristine valley to the south.

In search of funds to build a ski area, Poulsen formed a company with Alexander Cushing, a Wall Street lawyer, and Reily founded a corporation whose members were skiers of national prominence. Ultimately, both men lost control of their dreams to build a ski area. Poulsen was ousted by Cushing, and Reily failed to raise sufficient funds.

By 1960, Squaw Valley, having hosted the Winter Olympics, had become a world-class ski resort with extensive facilities and a lively community of permanent and part-time residents. Meanwhile, Alpine Meadows' investors and homeowners shunned commercial development and prided themselves on being a "family area—owned and operated by real skiers."

I grew up in the San Francisco Bay Area and enjoyed skiing on weekends and holidays with my family—first in Yosemite in the 1940s, then Sugar Bowl in the 1950s and 1960s before finally moving to Lake Tahoe in 1962 to raise a family and own a business. With friends from the city and the mountains, I've enjoyed a lifetime of watching the story of skiing in the Sierra unfold.

In 1961, my soon-to-be husband and I skied from the top of KT-22 in Squaw Valley down the backside of the mountain into a pristine valley with John Reily, who proposed to build a ski area called Alpine Meadows. It was love at first sight. The following year, we bought a lot and in 1964 built a house, where we lived with our three children for twelve years. My husband, a member of the 1960 Argentine Olympic Ski Team, was the head ski coach at Alpine Meadows in its early years, until we opened a ski shop down at the entrance on the main highway. We later added a shop at the mountain and a shop in Squaw Valley. From the 1960s to the present, we skied, worked and lived with all the players in both Squaw and Alpine.

After John Reily Jr. suggested I write the story of his father's contribution during the late 1950s and early 1960s to the development of Alpine Meadows, I knew I would have to write about Squaw Valley as well and that it would be a book as much about the place as the people who shaped the future of these two ski areas and the communities that support them. I thought that if Alpine Meadows and Squaw Valley were to join operations, it would provide a perfect conclusion to the story of a ski area (Alpine), conceived as an offshoot of its better-known neighbor. Five months later, the merger of the two areas was announced.

How these two valleys—so close geographically yet so distant philosophically—survived avalanches, fires, floods, lift accidents, economic ups and downs, ski trends, public opinion, good and bad management and how the corporatization of both sides of the mountain inevitably joined them as one is a story about the people who lived and made history in both valleys.

For a brief explanation of the ski area's name change to Palisades Tahoe in 2021, please see the epilogue.

All references in this book to the term *squaw* are purely for historical context and are not meant to be offensive or disrespectful in any way.

## Chapter 1

# MEN WHO LOVE MOUNTAINS

## WAYNE POULSEN

The dirt road from Truckee to Tahoe City at the north end of Lake Tahoe lay covered with snow in the winter of 1931 when Wayne Poulsen, a young ski competitor from Reno, made his way along the Truckee River to a ski meet on Olympic Hill, overlooking Lake Tahoe in Tahoe City. Before the canyon narrowed, he stopped to look west at the mountains rising above what appeared to be a great valley, and he wondered what lay beyond.

Having fashioned his first pair of seven-foot-long skis from Oregon pine when he was eleven and having thoroughly explored the mountains around Lake Tahoe—first as a Boy Scout and later as an assistant to James Church on their annual snow surveys around the lake—Poulsen was an accomplished skier and an experienced outdoorsman by the time he was sixteen.

Wendell Robie founded the Auburn Ski Club in 1929, providing the impetus for recreational and competitive skiing in the Northern Sierra. The club organized jumping and cross-country ski meets throughout the 1930s at Hirschdale, close to the railroad tracks near Truckee, and on a scaffold jump at Hilltop by the Truckee River. Poulsen often traveled by train from Reno (the only way to get there in winter) to jump at these meets with his friend and teammate Marti Arrougé.

When he told Marti about the mountains west of the road between Truckee and Lake Tahoe, Marti told him that his parents, who were Basque, brought hundreds of sheep to graze in a meadow there at the foot of the

Wayne Poulsen and Marti Arrougé—jumpers. *Courtesy of the Poulsen family.*

mountains. He described a campsite and creek where they spent every summer since he was a small child, and he promised to show Poulsen the valley.

In the summer of 1931, Arrougé took Poulsen into the valley to fish in a stream that meandered through the meadow. It was called Squaw Valley, so named for the many Washoe women found in the valley during the summer months while their men were up in the mountains hunting.

The following summer, Poulsen returned for another look at the granite peaks rising at the far end of the meadow, but before he could plot a route into those mountains, he was turned back by a gun-toting cowboy from the Smith Ranch whose family had been in the valley since 1862. Undeterred, Poulsen retreated along the creek, catching his limit of twenty-five trout on the way. The next day, he returned, took a different route up into the mountains, got a better look and caught another limit. Squaw Valley was in his heart and on his mind.

Poulsen entered the University of Nevada at Reno in the fall of 1933 and continued his jumping career in competitions and exhibitions. When the 1936 Olympics were held in Garmisch, Germany, Alpine skiing events caught the interest and attention of the skiing world, and Poulsen took to alpine skiing just as he had to Nordic. He raced in every kind of competition, winning the California Four-Way Championship—slalom, downhill, jumping and cross-country. As a college junior, he organized the university's first ski team and became both captain and coach.

By the time he graduated in 1938, he knew that Squaw Valley would someday be his home and that he would build a house there—perhaps even a ski resort. He had taken an option on 1,200 acres of the Smith Ranch in Squaw Valley the summer before "because [he] fell in love with it."

It was his good buddy Marti Arrougé, once again, who introduced Poulsen to his second love: flying. In 1940, as the war spread across Europe, Marti had become a flight instructor for the U.S. Air Force, and he encouraged Poulsen to do the same. After completing flying lessons in Reno, he waited to go to war in Europe with the British RAF, but he had to wait to be called for training. What better way to spend that time than to go to Sun Valley, Idaho, where they both could work as ski instructors? Poulsen, with his Scandinavian good looks—blue eyes in a sun-tanned face—and his confident ease on skis had only to look into the eyes of his one and only student, a pretty girl from New York named Sandy Kunau. They fell instantly in love and remained so for the rest of their lives.

After their wedding in August 1942 and a year of flight instructing for the U.S. Naval Air Force, Poulsen flew ammunition, men and supplies

in the Pacific with Pan Am, whose planes had been requisitioned by the navy. His career as a pilot with Pan Am would continue for thirty-one more years.

# Poulsen and His Valley

In 1943, Poulsen purchased 640 acres from Southern Pacific at the head of the valley—the place he and Sandy and their growing family headed whenever he was on leave. They camped there by a rushing stream that leaped over granite boulders in a series of falls and pools from the mountains above.

In the summer, they drove in on a dirt road, often getting stuck in the mud while attempting to cross the creek. In the winter, they skied in and then climbed the mountains using sealskins to keep their skis from slipping backwards. One mountain was so steep and the snow so heavy that it took Sandy twenty-two kick turns to reach the bottom, inspiring Poulsen to name the mountain KT-22.

In 1947, the Poulsens built their home on Squaw Valley Road, completing it in time for Christmas dinner, which was cooked in the fireplace with snow blowing through glassless windows. They had no running water, no electricity and no plumbing, but they were home, surrounded by the land and the mountains they loved.

Now living year round in the valley, the Poulsens began to seek investors to develop their resort. They bought an army surplus weasel to pull friends, skiers, pilots and fishing pals on a rope across the meadow, where they could look up and admire the mountain slopes they hoped to develop. They had a lot of fun, but no one offered to invest.

The following winter, while skiing at Alta, Utah, Poulsen and Sandy met an East Coast lawyer, Alexander Cushing, who was interested in buying a ranch in California. They invited him to come and see their valley. Later, in the spring of 1948, Cushing, with his wife, Justine, and her sister and brother-in-law, Alexander McFadden, came west to ski at Sugar Bowl and take a look at Squaw Valley. Having broken his leg at Sugar Bowl, Cushing admired the valley and the soaring snow-covered mountains that surrounded it from the back of the weasel as they towed the rest of the party across the meadow.

Alexander Cushing, born and raised in New York and Rhode Island, was educated at Groton and Harvard. He graduated from Harvard Law School

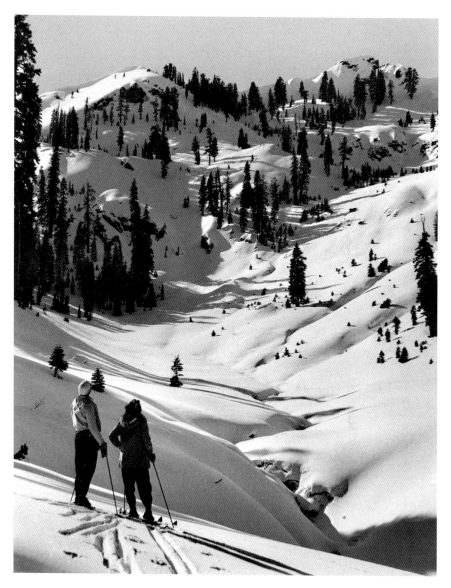

Poulsen walking up KT-22 1940s style. *Courtesy of the Poulsen family.*

and practiced law on Wall Street before joining the U.S. Navy the day after the attack on Pearl Harbor. After five years serving in South America and the South Pacific, he returned to civilian life and found that Wall Street had lost its allure. Like many men before him, something—perhaps a latent pioneer spirit—drove him to seek his life and opportunity in the West.

View from Poulsen family home, Squaw Valley, 1940. *Courtesy of the Poulsen family.*

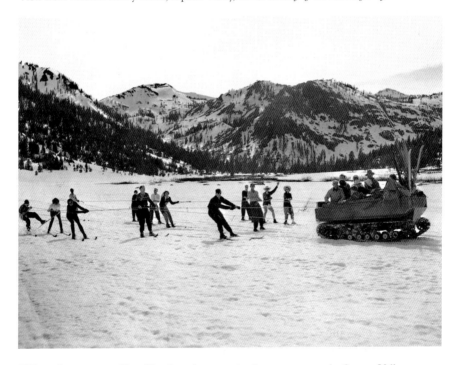

"Clipper" snow cat pulling friends and prospective investors across the Squaw Valley meadow, spring 1948. *Courtesy of the Poulsen family.*

His wife, Justine Cutting, equally adventurous and well connected with wealthy families on the East Coast, helped her husband gather several friends and collectively raised $400,000 (including $50,000 from Laurance Rockefeller). Poulsen contributed his 640 acres, and they formed the Squaw Valley Development Company. Poulsen was president, while Cushing, whose investors owned a majority share of the company, was secretary-treasurer. In June 1948, Poulsen exercised his option to buy 1,200 acres from the Smith family.

Having known and loved Squaw Valley for over a decade, Wayne, Sandy and their growing family of seven had an emotional bond with the land. They favored a cautious approach to development. Cushing, however, was eager to develop Squaw Valley into a ski area that would rival all others and reward both him and his investors. Poulsen and Cushing were both strong-willed, determined men who, according to Poulsen, "disagreed on just about everything."

As a full-time pilot for Pan Am, Poulsen was often away for long periods of time, and it was during one of his trips in October 1949 that Cushing called a stockholders' meeting. With the majority of original investors from the East Coast, they elected Cushing president. Poulsen was out of the Ski Corporation. He lost his 640 acres at the head of the valley and his dream to build a ski area. However, with his 1,200 acres, Poulsen owned everything else in the valley.

# JOHN REILY

John McClintic Reily grew up in San Bernardino, California, on the grounds of the Patton State Mental Hospital, where his father, a psychiatrist, was the director. After graduating from Stanford University in 1929 with a degree in economics, he married Winnie Rule in 1935 and then embarked on a honeymoon cruise through the Panama Canal to New York, where they would make their new home. Reily went to work for Weeden & Co in stocks and bonds, where, in spite of the market crash, the company thrived and he became manager. His first son, John Milner, was born in 1936, followed by two daughters, Joan and Priscilla.

Ever the avid and innovative skier, Reily taught his children to ski on a rope tow he installed on the fifteenth hole at the exclusive Ardsley Country Club, located on the Hudson River twenty miles north of Manhattan. Reily

John and Winnie Reily. *Photograph by Donald E. Wolter.*

had skied in all the major New England ski resorts, including Tuckerman's Ravine, Bromley and Stowe, Vermont.

When the family returned to Los Angeles in 1947, they moved into a large Mediterranean-style house in Hancock Park, within walking distance of Reily's new position at Carnation Co. Winnie, reunited with her lifelong friends, enjoyed an active social life. With all three children

in high school, the family spent summer days at the Santa Monica Beach Club and skied during the winter at Big Bear and Snow Valley, with Reily venturing farther north to Yosemite and Sugar Bowl on Donner Summit. By 1953, Reily was treasurer of Carnation, president of the Southern Ski Club of Los Angeles and chairman of the L.A. Chamber of Commerce.

Life was good in L.A., but when Reily heard that Squaw Valley, having just opened in 1949, might host the 1960 Winter Olympics, he and Winnie went to ski there in the spring of 1955. They found the valley busy with plans and preparations. Skiers from the San Francisco Bay Area and Sacramento and transplanted easterners were building houses along the road that led to the lodge and the lifts. Reily, who had always dreamed of having a cabin in the mountains (in fact, he felt everyone should have one), bought a house on a hill across from the future site of the Olympic ice arena and named it Berghof.

# REILY AND HIS VALLEY

On a warm summer day in August 1957, John McClintic Reily rode out from the Squaw Valley stables with his twenty-one-year-old son John Jr. across the meadow and up a steep, rocky trail, letting their horses pick their way to the top of KT-22. They stopped in the shade of a grove of pines and looked back at the meadow, the empty parking lot and the small lodge at the head of the valley. Empty chairs hung motionless in a windless sky. "Come see this," Reily said to his son. Holding his reins in one hand, he pointed in the opposite direction, to the southwest, where a pristine valley fell away below a protective ridge of high peaks.

A few splotches of green hinted of aspen groves and small meadows fed by alpine springs and a creek that carried melting snow from the cirques high in the mountains down the valley and out of sight. "I think that could be a good ski area," he said. "With all of the activity going on in Squaw—the Olympics and all the stuff they are going to build—I'll bet this valley would be a good place to ski."

On the way back down the mountain, Reily told his son that skiing in California would be forever changed by the Olympics—better roads, more accommodations, more people living year-round in the North Tahoe area—not to mention all the publicity. He described his vision of a ski area that would

Looking at Ward Peak and Bear Creek Valley from the top of KT-22. *Photograph by Donald E. Wolter.*

eschew the glitz and glamour of Squaw. Instead, it would be "a skier's ski area—just fine skiing without a lot of development, planned by skiers with an emphasis on families."

## ALEX CUSHING AND HIS SKI AREA

Squaw Valley's grand opening was scheduled for Thanksgiving Day 1949. Alex and Justine Cushing greeted their guests in front of the fireplace in Bar One of the *almost* completed lodge. Wearing his customary turtleneck under a tweed jacket and a slightly lopsided grin (caused by a partial paralysis when, as a lieutenant commander in the U.S. Navy, he collapsed after a sixty-hour mission with no sleep), he told no one that union workers had stopped construction on the lodge just days before the opening, resulting in his having to hire strikebreakers to finish the job. Nor did he tell them that he had to repair the plumbing himself, that only one toilet was working and that

*Above*: Squaw Valley Lodge, 1948. *Photograph by Bill Briner.*

*Right*: Squaw One, the "World's Largest Ski Lift," 1949. *Photograph by Bill Briner.*

Alexander at the keyboard in the Beer Garden. *Courtesy of Squaw Valley Ski Corp.*

there was no running water. Years later, in an interview with *Time* magazine, Cushing revealed additional horrors. "That night, everything went wrong," he said. "There was no dinner until 10 p.m." One of their daughters broke her leg, and the family dog was run over.

Undaunted and underfinanced, Cushing pressed on. The fifty-room lodge reopened for the Christmas holidays, and Chair One, "the world's largest ski

Party Time Bar One, Squaw Valley Lodge, 1950s. *Courtesy of Squaw Valley Ski Corp.*

lift," carried skiers up Squaw Peak. The Cushings entertained family, old East Coast friends (including Laurance Rockefeller) and new West Coast friends at lunch on the deck, where they could watch skiers descending the Mountain Run.

Guests, who tended to know one another—either on the East Coast or in San Francisco—dressed for dinner and congregated afterwards in the Beer Garden downstairs, where they joined Hollywood ski enthusiasts such as Sophia Loren, Gene Kelly, Bing Crosby, Clark Gable, Ann Miller and others. Dorothy Earle, Norma Shearer and Jock McLean added a touch of glamour, especially when they participated in music revues and song fests and danced to live music with Cushing adding his jazz renditions on the piano.

## Chapter 2
# SNOW JOBS

## HEADWALL

Headwall, the source of devastating avalanches that plagued the area throughout the 1950s, rises 700 feet up from the terminal tower of Chair One. In order to control the buildup of ice and snow on its cornice, which stretches ominously across the horizon at 8,700 feet, patrolmen had to climb to the top, usually in a howling blizzard, and "ski off" the overhang before it built up enough to fracture and plunge down the mountain.

Expert skiers yearned to ski on Headwall's wide-open, unblemished and almost perpendicular face. They knew that access to the top would open up the slightly less perpendicular north-facing slopes that dropped down into Siberia Bowl, as well as the ridge to the south and the saddle. A second lift to the top of the Headwall would make this possible. The U.S. Forest Service, however, had issued only one lift permit for "recreational use." Not one to be deterred by government regulations and showing a nascent talent for interpreting rules to his advantage, Cushing proposed building a lift to the top of Headwall for "avalanche safety." The ski patrol could carry dynamite to the top or lob hand charges from the lift (and expert skiers would have acres of challenging new terrain).

Bob Heron, the engineer from Denver who had built Chair One, was called back in 1951 to construct a lift from the top of Chair One to the top of Headwall. With no steel available for lift towers (due to the war in Korea), two towers were constructed of heavy wood beams, supporting a

Headwall Jigback lift. *Courtesy of Squaw Valley Ski Corp.*

one-thousand-foot-long cable from the bottom tower to the top of a rocky cliff. In high winds, the six chairs carrying twelve skiers could speed up to the break-over point on the summit and then inch along carefully to the unloading ramp. Designed as a temporary solution, it proved its durability in high winds and continued in operation until 1969.

# Avalanches

Over the next five years, three separate avalanches roared down the mountain, taking out lift towers and flinging cables across the slopes. In January 1952, a severe blizzard swept across the Sierra, closing passes, roads and the ski area. Joe Carson, the lift operator whose job it was to dig out the bull wheel when they started the lift, had been waiting out the storm in the lift shack at the top of the Squaw One lift for three nights. When he radioed to mountain manager "Big John" Mortizia that he wanted to come down off the mountain, Big John advised him to wait for a rescue party. But staying in that shack and listening to the whine of the wind and rumble of unseen avalanches for another hour must have seemed worse to him than venturing out into the storm on snow shoes. Two rescuers set out immediately. They found the shack empty when they arrived—no trace of Joe. They returned to the base to organize a search party of fifty volunteers. Blinded by howling gusts of snow that blew horizontally across the ever-shifting terrain, they made their way up the mountain, probing with rods and straining to see a dark spot in the infinite white space that enveloped them. Tracks were obliterated instantly. When exhaustion and the futility of their search sank in, they followed the lift lines back down to the bottom.

The next morning, when Big John started the lift, "it shuddered and shook and stalled, and we knew something was wrong," he said. Later, they discovered that a huge avalanche had rolled off the slope above Tower 16, taking out towers 12, 13 and 14. They didn't know if this occurred before or after their search. Joe Carson's body was found in June.

In 1958, Stan Tomlinson, ski school director, was teaching a class in the bowl just off the top of Squaw One when an avalanche roared down Headwall, leaving his astounded class to watch their instructor being swept away in a cloud of snow. Tomlinson recalls the avalanche in vivid detail in Jane Feidler's *A History of Squaw Valley*:

> *I heard this big roaring sound, and it flashed through my mind that it was surely a strong gust of wind to make all that noise. And then "BLAM!" This thing—something hit me in the back, and I was down on my face and underneath. It was the Headwall that slid. It just rolled me and tossed me…like being tumbled in ocean waves…crashing all the way from near the top of the first bowl and all the way down to the flat by Tower 20. I couldn't see anything. About halfway down, just across from Tower 22, is a place where the slope levels off a little bit with a little bump where a tree grows. I went right over that thing in the avalanche. For a moment, I was*

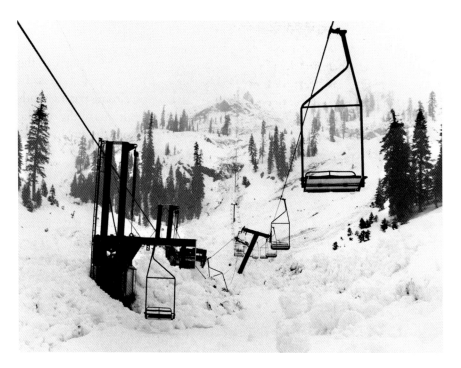

Aftermath of an avalanche. *Courtesy of Squaw Valley Ski Corp.*

*in the air, out of the avalanche. I could see what was going on as I flew through the air. Of course, when I landed, the thing was all over me again. I thought…really thought I was dead…thought I was going to die, but I just kept struggling to stay upright somehow. As it started to slow down and fan out, my head, arms and shoulders came out. And it stopped. That was it.*

Avalanches were always a threat in Squaw Valley, and although they sometimes resulted in tragedy, Squaw's challenging terrain and severe weather patterns created the perfect laboratory for their study and control. Monty Atwater, Dick Reuter, Norm Wilson and many others became experts in snow safety and avalanche control. They contributed much to improve the safety of skiers throughout the 1950s and years to come by passing their knowledge and experience on to younger patrolmen.

# WHY NOT SQUAW?

Avalanches were not the only natural disasters that plagued the valley during its first five years. Floods closed the lodge twice and on four occasions washed out bridges and the dirt road, isolating the ski area from public access. And in 1955, the lodge burned to the ground.

In spite of these setbacks (or because of them), Cushing did not give up. He needed some positive press. In 1954, he read an article in the *San Francisco Chronicle* that Reno, Nevada, was being considered as a site for the 1960 Olympics, and he wondered, "Why not Squaw Valley?" Although it was highly unlikely that Squaw could qualify with such limited facilities, at least it would get Squaw's name in the paper for something other than floods, fires and avalanches.

Squaw's one-man marketing department was off and running—first to San Francisco for a story in the *Examiner* (after the *Chronicle* turned him down), then to State Senator Bizz Johnson of Placer County for funds and then to Governor Goodwin Knight for support. Both had read the article in the *Examiner* on Reno's bid for the Olympics and agreed that an Olympic bid would be good for California. In fact, a majority of the state's senators had read the article, and they supported Johnson's bill to allocate $1 million for Cushing to pursue his plan.

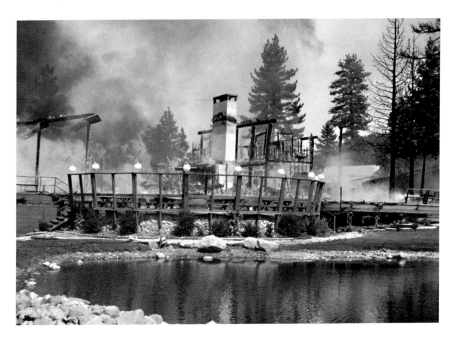

The Squaw Valley Lodge burns. *Courtesy of Squaw Valley Ski Corp.*

The United States Olympic Committee site selection meeting was scheduled in New York in January 1955. When Cushing told Albert Sigal, a board member of the National Ski Association and a member of the selection committee, that he didn't plan to attend the meeting, Sigal responded that it would be an insult to apply and not attend. Although he saw little chance of winning over better-known areas such as Aspen, Sun Valley, Lake Placid, Reno or even Alaska, Cushing went to New York.

He answered all their questions and convinced them that Squaw Valley had the mountain, the snow and the financial backing. The fact that there was only one lodge, one chairlift, two surface lifts and a dirt road raised a few eyebrows.

The next hurdle—an even higher one—would be the International Olympic Committee (IOC). On his way home, Cushing stopped in Chicago to meet Avery Brundage, the newly elected president of the IOC, who expressed his complete lack of support with statements like, "I think the USOC has taken leave of its senses" and "If you ask me, the whole place [Squaw Valley] is a figment of Cushing's imagination" and "You can't win, so I don't have to worry about it." Brundage made clear his certainty that Squaw would have no chance at the March IOC meeting in Paris.

Cushing's ease and grace in social situations made him believable and sympathetic to the European aristocracy. He also had friends in all the right places, including Laurance Rockefeller in New York, Harvard classmate George Weller, who was Paris bureau chief of the *Chicago Daily News*; expat man-about-Europe Marshall Haseltine; and Joe Marillac, ski school director at Squaw and a revered hero of the French underground during World War II.

Hiring French Olympic ski champion Emile Allais to head the ski school (instead of an Austrian, like most ski areas) was Cushing's first unconscious but brilliant step in securing the Olympics; for it was Emile who brought Joe Marillac to Squaw Valley, and it was Joe Marillac who convinced the skeptical Europeans (especially the French) that California does have mountains, snow and the terrain for international competition. Having been named "Officier de Merite Sportif" in 1950 (France's highest athletic award) and being a member of the Chamonix Mountain Guides and the elite Groupe de Haute Montagne (along with his friend, Maurice Herzog), Marillac had more credibility in the Alpine countries than any delegate from any other part of the world. He was more than just a mountaineering legend—he was a national hero. He had collected and delivered guns to the French Resistance and had been arrested by the Gestapo and escaped three

Joe Marillac in the Beer Garden with daughter Missy. *John Corbett Collection, Squaw Valley Ski Corp.*

times before leaving his life as mountaineer and guide in Chamonix for more adventures in the United States.

Three weeks before the IOC would convene in Paris, Marillac was dispatched to Montreaux, Switzerland, where the Federation International du Ski (FIS) was meeting to study the technical requirements for Alpine

events, i.e. vertical drop, steepness, etc. Europeans believed Americans could build anything faster than anyone, but did they have the mountains? Much to their surprise, Marillac assured them, "Oui, c'est vraie."

After a serendipitous encounter with Cushing in St. Moritz, George Weller was intrigued with the possibility of the first Olympics to be held in the Western Hemisphere. The two friends put their heads together to discuss their theory that, "the Olympics belong to the world," and began strategizing how to convince the IOC that the games could be held somewhere besides

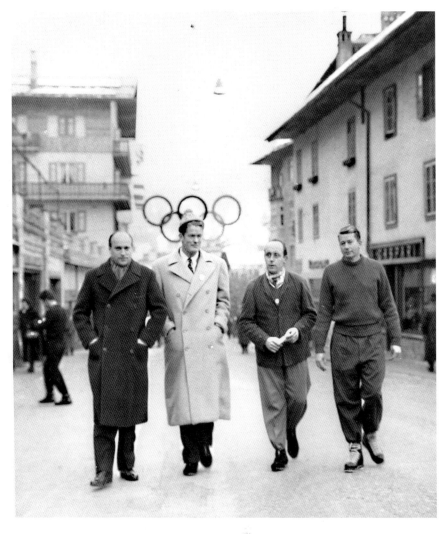

Cushing goes to Cortina with Marshall Haseltine (*left*), George Weller (*center*) and architect Adrian Malone (*right*). *Courtesy of Squaw Valley Ski Corp.*

the usual four Alpine nations. When Weller came to Squaw and saw how meager the facilities were, he reacted not with despair but with hope! The games would return "to simplicity," where "athletes would be secluded from commercial pressure and live together as friendly sportsmen in an Olympic Village off limits to the press and the public." In other words, lacking an existing village, they would build one.

Weller, who spoke five languages, ordered brochures to be printed in Spanish as well as French, German and English. He then traveled to South America to secure those nations' support, noting in a brochure that "the peoples of the Pacific region, who have never had the Winter Games, would be enriched by a new transplanting of the Olympic spirit." Even more convincing, he said, "Canada and the United States have been sending teams to Europe both summer and winter for the past twenty-five years. The United States, with its estimated 50 million followers of winter sports, is today the largest participant in the Winter Games. This consistent support of the Olympic spirit deserves recognition."

He charmed the Scandinavians with promises to hold a biathlon and to keep expenses down through financial support from the state of California. Meanwhile, in Paris, Cushing set up his model of Squaw Valley at the U.S. Embassy, as it was too big and unwieldy to get through the door at IOC headquarters, where all of the other contenders met. Personally escorting each IOC member to the embassy to view his model, Cushing got a little extra schmooze time away from the competition.

On a hot afternoon in June, the delegates gathered to hear presentations from Garmisch, Innsbruck (the presumed winner) and Squaw Valley. With Cushing, Marillac and Weller beside him, Haseltine impressed the IOC by making the presentation in French—the *lingua franca* of the IOC. After twenty minutes of questions and a summary by Haseltine in French, the Squaw Valley contingent waited in a hallway for St. Moritz to present. On the first ballot, St. Moritz and Garmisch were eliminated, leaving Innsbruck with twenty-six votes and Squaw Valley with thirty. The second ballot resulted in a tie.

The following morning, Cushing returned to answer more questions on quantity of snow (too much could be as big a problem as too little), potential threat of moral corruption in Reno (French humor?), local government restrictions (there was no local government) and the obvious questions about costs and facilities. Cushing answered their questions with wit and sincerity and then returned to the hallway to wait. When reporters streamed from the meeting room to phones shouting, "It's Squaw Valley!" Cushing and the Innsbruck delegation were equally stunned.

Brundage congratulated Cushing, saying that he was concerned there would be a tie and his vote would decide the outcome.

"How would you have voted, Mr. Brundage?" Cushing inquired.

"Well, you know, I was against you, but I am an American."

"What would you have done?" Cushing persisted.

"Jumped out the window."

## Chapter 3
# THE VALLEY NEXT DOOR

### GREAT EXPECTATIONS

By 1956, preparations for the Olympics in Squaw Valley were well underway, and enthusiasm for the games and expectations for the numbers of visitors that would come was the talk of the state. Poulsen, who had explored the adjacent valley long before 1949 when he lost his dream of building a ski area in Squaw Valley, decided to revisit his idea of connecting the two valleys with a chairlift up Papoose Peak in Squaw and another down the other side, where a series of Poma lifts would access nearby slopes.

To this end, he hired architect Paul Jacques Grillo to design a master plan on twelve acres of his land zoned commercial. Grillo noted that the Olympic facilities would be built on land owned by the state and would thereby be temporary, whereas Poulsen's projected facilities would be permanent for local residents to enjoy, as well as "thousands of sports fans and vacationists."

The first phase called for a community center at the base of Papoose, described by Grillo as "a friendly and happy place for meeting people, who should soon consider it as a home for social activity and fun—a sort of lobby for the Valley folks, a friendly and elegant place to shop and meet friends."

The second phase added "a heated pool with three lanes and a physiotherapy or athletic club combining doctor's offices, gymnasium and sauna, cabanas, hotel type of lodging and a super market that would include a drugstore and department store." The complex would also have

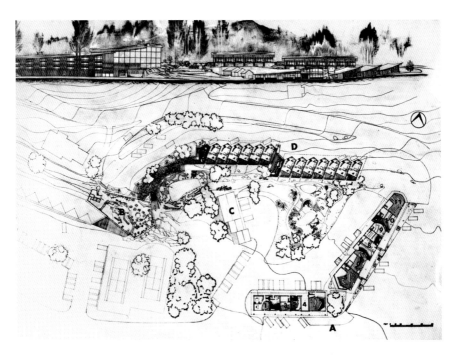

Grillo's architectural drawing for a village at the base of Papoose. *Courtesy of the Poulsen family.*

a bank, post office and a gas station. Grillo's description concludes, "A pond graces the south end of the general store, where snow melts from the folded roof gutter into a gigantic icicle that becomes a water fall during summer months."

Letting his imagination soar, Grillo proposed a 120-room hotel with a theater "under a ski-run type of roof that allows summer skiing on its plastic rush mat cover, and on which skiers can have fun while they wait to board the téléferique to Papoose Peak." There was a restaurant and a ski shop, and Squaw Creek would be "widened into a small lake for swimming, bordered by a beach and dug-in cabanas on the north side."

Clearly, Grillo (and presumably Poulsen) believed Squaw Valley would attract thousands of visitors year round for years to come, and they envisioned a huge sports village designed for permanent residents in numbers far exceeding reality.

Reminiscing years later, Poulsen remarked:

> *In the early 1950s, I drew a plan to ski from Alpine Meadows and all the way to Lake Tahoe. My plan was never to go up there with a road, and*

*as it turned out, when Alpine went bankrupt—I guess they never declared that, but they were bankrupt—the amount of money they owed was almost identical to what that road cost.*

Poulsen and Sandy both remember almost buying Alpine Meadows and Five Lakes for $2,500. "Isn't that something?" Sandy said prophetically, years later. "And now it's stalemating Squaw Valley because the Forest Service bought it and they put it into Rare II, so you can't go across."

## Great Migrations

When the news was out in 1956 that the greatest ski show on earth would take place in a little-known California ski area, skiers, speculators, entrepreneurs and dedicated ski bums from coast to coast came to Squaw Valley, all looking to be part of the action in 1960. Some bought land from Poulsen and built houses. Bay Area and Central Valley residents drove for hours on a two-lane highway, risking the elements and hazardous road conditions over Donner Summit to stay at the lodge or to spend a "weekend at the cabin." Many stayed to ski and help build facilities for the games and later found permanent jobs, opened businesses, married, raised families and never left.

David Tucker, an architect just out of grad school at UC Berkeley, thought he would build a spec house and rent it for the games. He ended up living in it for the next forty years. John Sproehnle, on the recommendation of an army buddy, joined Willy Schaeffler's packing troops. As an expert skier, he got to do the final stepping and sliding (after the boot packers), skied with Olympians, met his wife, Jean, and went back to Stanford briefly before choosing to return and live in Squaw for the next fifty years. John and Sally Hudson came to open a branch of their Los Angeles ski shop, Sporthaus West, in Squaw Valley. Sally, a member of the 1952 U.S. Olympic ski team, stayed in Squaw the rest of her life and raised three sons, including 1988 U.S. Olympic ski team member Bill Hudson.

Your author volunteered as a guide at the Olympics for the IOC, met and married a member of the Argentine Olympic team and returned to live in the area in 1962.

Henrik Bull first visited San Francisco when he was twelve and vowed to return to "that beautiful city—just 200 miles from skiing in the Sierra Nevada." An avid skier and outdoor enthusiast, he grew up skiing in Stowe,

Vermont, so of course he went to Squaw shortly after he arrived in 1954. When Bull first set ski boot inside the lodge, he heard a familiar voice. It was Peter Klaussen, his roommate while living in Boston after Bull had completed his degree in architecture at MIT and Klaussen his in business at Harvard. After expressions of delight and surprise at finding themselves together on the cusp of Olympic history, Klaussen revealed that he wanted to construct a house in Squaw to sell or rent during the Olympics. Poulsen showed them available lots, and Klaussen bought one for $2,500. Then the two old friends put their heads together—Bull to design, Klaussen to build.

On learning that Klaussen had never built anything, Bull decided to design something simple that would be easy to construct. Ten days later, on seeing the design, Klaussen said, "Henrik, this is not very exciting." Klaussen brushed away Bull's concern for his abilities to build a more complicated structure, and they returned to the drawing board as a team. The result was a two-page spread in *Sunset* magazine that generated one thousand letters from readers asking for information or plans. When the house won the Honor Award in the biennial American Institute of Architects/*Sunset* magazine Western Home Awards, Bull's reputation as a snow-country architect was established. He and Klaussen collaborated on two more *Sunset* award-winning homes. Bull, now eighty-two and retired from a lifelong career of designing award-winning homes and buildings (half of which are in snow country), credits Klaussen with many imaginative and innovative ideas that helped launch his career.

# GREAT EXPLORATIONS

Peter Klaussen left the corporate world and a secure position at Polaroid in Boston to move to Sausalito, California, in 1955. He knew that architecture, design and building houses interested him more than business, and he loved everything to do with mountains. When Monty Atwater, a U.S. forest ranger from Alta, Utah, and the country's foremost snow safety and avalanche expert, was hired by the U.S. Olympic Committee to direct avalanche control in Squaw Valley, he hired Klaussen in 1956 as part of his team, and together they explored the surrounding peaks and valleys.

On one of their expeditions, they skied along the mountain ridge south of Squaw Peak, taking in the view of Ward Peak, the highest mountain on the horizon at 8,640 feet. While focusing their binoculars on the overhanging cornice along the ridge on either side, they saw four glacial cirques protecting

Looking at bowls in Alpine Meadows. *Photograph by Donald E. Wolter.*

a series of bowls that ran out into a wide, flat area. Atwater studied the avalanche potential, while Klaussen thought about skiing in those open, treeless bowls.

That same winter of 1956, the United States Olympic Committee (USOC) sent Willy Schaeffler, the Austrian mastermind of FIS and Olympic race courses, to Squaw Valley to design the courses for the upcoming Olympic events and, with Nelson Bennett (also an FIS technical delegate and director of ski events in 1960), to survey the surrounding mountains for potential sites for other venues. In search of a site for the first Olympic biathlon, they went by Weasel up into neighboring Bear Valley, and although they deemed the area too remote and inaccessible for an Olympic event, the two men noted the area's potential for a ski resort.

Meanwhile, John Reily's weekend visits to his cabin in Squaw began extending into weeklong visits. His enthusiasm for mountain living grew, and with it his desire to plan and develop a ski area of his own. Inevitably, he too began to explore the valley next door.

TALES FROM TWO VALLEYS

In the spring of 1957, Reily turned off Highway 89 at Deer Park Lodge and drove his jeep up a logging road along Bear Creek through groves of aspen trees as far as he could go. Having looked down into this valley in winter from the top of the KT lift and, later that summer, from the top of a horse, Reily knew that this was where he would build his ski area.

During the following winter, as thousands of skiers came to Squaw Valley to see and to ski the country's first U.S. Olympic site, Reily arranged ski tours from the top of KT down into his valley, where a Weasel waited to carry them to Highway 89. Encouraged by the interest in their planned endeavor, Reily and his son applied for a U.S. Forest Service permit in July 1958. The permit would be granted after the Forest Service surveyed and studied the area through the coming winter and after they obtained "access from Highway 89 to the area to be developed."

Reily accomplished that by signing a twenty-five-year lease on July 1, 1958, for fifty-six acres on the backside of KT, with an option to renew for another twenty-five years in June 1983. The lease stated that Reily had the right to "select a 50 foot wide ski strip for a ski lift across the north half of said section 5 and a site adjacent thereto not to exceed 5 acres for a restaurant in the north half."

Reily and his son John now had control of the road into the valley, as well as a fifty-year lease that included the top of Papoose and KT-22—lift towers and offramp included.

In October of the following year, the Forest Service granted the Reilys a permit to develop a ski area "on the condition that the Reilys, or a corporation to which the Reilys wish the permit issued, obtain financing sufficient to accomplish the construction of one chairlift, one T-bar, two rope tows, buildings, water systems, power system, parking and other facilities."

# A GREAT LOCATION

Later that summer, while painting the exterior of Reily's house, Peter Klaussen listened to Reily praise the benefits of owning a cabin in the mountains and his desire to share his good fortune with others. He told Klaussen of his plan to develop an area in the next-door valley with home sites and ski lifts. Pleased to find someone familiar with the area, he invited Klaussen to accompany him on a picnic excursion into the valley with like-minded homeowners John and Sally Hudson. Along the way, Reily showed them where he would build a lift on

the backside of KT so that skiers could ski down from Squaw Valley. A second lift farther down the road would go to the top of Papoose, also accessible from Squaw. A weasel could transport skiers up the road in winter.

Klaussen looked dubious when Reily asked his opinion. Having surveyed the area for avalanches, Klaussen knew that slides were frequent along the windy ridge between the two valleys. With its southern exposure, snow on this side would be of poor quality and melt early in the season. It was also very steep—an area for expert skiers only. A better choice, Klaussen advised, would be farther up the valley on Ward Peak.

When they reached the meadow and spread their picnic out on a fallen log, Klaussen told Reily that instead of developing a modest ski area with skiers coming from Squaw Valley, he should think big. He wanted to build a ski area independent of Squaw. Klaussen pointed to where ski lifts might be built up Ward Peak. Reily (now thinking really big) had skied in Europe, where gondolas span deep valleys, and he thought a gondola from KT to Ward Peak would be quite spectacular. He believed this would attract visitors year-round (although it would only be accessible from Squaw). A restaurant with a view of Lake Tahoe and the two ski areas would be an added attraction.

While the three men discussed the pros and cons of gondolas, Sally Hudson looked at the profusion of purple lupine in a small meadow and then up at the mountain, where snow lingered in the high cirques. "John, I think you should call your ski area Alpine Meadows," she said.

# A Test

Three years after Squaw was awarded the Olympics, IOC president Avery Brundage continued to assert in the press and to anyone who would listen that Cushing could not possibly transform his obscure little ski resort into a worthy Olympic site and that Cushing would bring shame and disgrace on the Olympics. Although Cushing sent progress reports to the U.S. and International Olympic Committees, Brundage had not yet visited Squaw Valley to see for himself. Having described Squaw Valley as "a hole in the wall" to his Olympic Committee colleagues, he believed Cushing had sold the IOC a bill of goods and that a flop of Olympic proportions was in the making.

In spite of the fact that the U.S. Olympic Organizing Committee and the California Olympic Commission had raised sufficient funds, the ski jump was up, speed-skating rinks were in place and athletes' dorms and administrative

and press buildings were complete. But Squaw Valley still had to prove itself on the mountain, and the North American Alpine Championships, scheduled for February 1959, would prove Squaw's readiness. Just one year before the 1960 Olympics, this was a dress rehearsal. The only problem: the stage was set on the slopes of the Sierra Nevada.

Athletes, coaches and officials from fourteen nations and U.S. and Canadian Olympic hopefuls arrived in Squaw, eager to compete on the future Olympic runs. They stepped out of their buses into ankle-deep puddles, sloshed their way to the dorms and then waited two days for the rain to stop. The rain turned to snow for two more days, raising their hopes, but before the boot packers could get to work on five feet of new snow, high winds whipped it into huge cornices on all three peaks (Papoose, KT and Squaw Peak). Despite the heroic efforts of Monty Atwater and his men blasting from dawn until noon with recoilless rifle fire and hand charges, only some of the cornices came down—many sliding on their own. They would have to close the mountain, and there would be more waiting.

When Atwater announced that Squaw Peak could not adequately prepare for the men's downhill event, they moved it to KT, but snow continued to slide from all directions. Maybe all the races would have to be held on Papoose.

More rain resulted in flooded bridges and impassable dirt roads, followed by three days and four feet more of snow. There was no gas station in Squaw, so there were no tire chains. There was not yet any telegraph service in the valley, and telephone lines through the hotel switchboard were jammed. A fire had damaged four rooms in the new athletes' village, while an avalanche had hit the ski jump. Perhaps Brundage was right.

At last, the weather cleared. Roads and puddles dried up, phones worked, cornices came down, boot packers went up and floundered from top to bottom in hip-deep snow, followed by sidesteppers with skis and side-slippers, and finally racers began to think about racing. Willy Schaeffler grumbled over changes in locations for his courses but gave in to officials, as they altered training and competition schedules and moved courses from one mountain to another. They would run the slaloms first on Papoose, giving more time to pack and prepare the giant slalom and downhill. A brilliant sun made practice runs on the men's downhill slow and slushy—a condition many racers and officials feared—but after a night of freezing temperatures, some of the best racers flew off the course, and those who finished ceased to complain that it was too easy.

On Saturday morning, the two slalom events started on schedule, with Stein Erickson and Freidl Pfeifer forerunning their courses. Buddy Werner and Linda Meyers won for the U.S., and everything else went off as

After a Sierra storm. *Photograph by Hank de Vre.*

rescheduled. Friedl Wolfgang, the FIS technical delegate for Alpine events, pronounced the courses good but had some concern for the men's downhill and a final suggestion that Squaw be prepared with hundreds of packers and alternative dates. He had experienced firsthand the ferocity of a Sierra storm and the determination of a no longer-obscure California ski area.

## UNDER CONSTRUCTION

As soon as the snow melted in spring 1959, cement trucks, bulldozers and earthmovers rumbled up the dirt road into Squaw, plowing through the pines and around boulders to build roads and bridges and to clear space for buildings. Dusty pickups rattled along behind them, bringing engineers, contractors, carpenters, plumbers, welders and electricians to build the ice arena, athletes' lodge and cafeteria and the California and Nevada Visitors Centers. The sounds of jackhammers, chain saws and pneumatic drills echoed from the granite peaks.

John Reily was also building: two A-frame houses in Alpine Meadows to be used as an office and a destination for visitors to his side of the mountain and a restaurant at the top of KT-22 aptly named The Cornice.

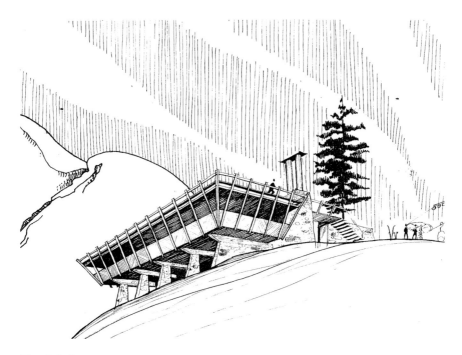

Henrik Bull's architectural drawing of Cornice Restaurant. *Courtesy of Henrik Bull.*

With the dual purpose of marking his territory on top of KT and establishing a lookout over Alpine Meadows to woo investors, Reily hired Klaussen's friend, Henrik Bull, to design the building. The first design was cantilevered out over a cliff, much like a cornice, with an observation/dining deck on top (similar to present High Camp, also designed by Bull), where snow would blow off and away from the building during storms. Paul Avery, his contractor, told Reily a sloping roof would be better, and Reily asked Bull to change the design. The second design (with a sloping roof) had a deck on the front of the building with a view of Lake Tahoe. The third design changed the slanted windows looking down the mountainside and moved the deck around to the side. When an aluminum window manufacturer in Los Angeles convinced Reily he should change the windows from wood frames to aluminum, Bull resigned. Henrik Bull, twenty-eight at the time, never resigned from a project for the rest of his long career.

The building was completed by Jim Morton, who later designed Reily's home in Alpine Meadows and many fine buildings in the area. Construction was facilitated by use of the road up KT built by Lowell Northrop to install the chairlift. During the Olympics, the building was used as a transmission center for television. It reopened as a restaurant in the summer of 1960.

## Chapter 4

# BIG DREAMS

### REILY ON A ROLL

In April 1959, John Reily, Peter Klaussen and a group of consultants from John Graham and Company (architects and engineers in Seattle and New York) visited Alpine Meadows by weasel. Reily had requested they undertake a planning and feasibility study of Bear Creek Valley for location of a ski resort. They had just completed a similar study for investors in Crystal Mountain Ski Area in Washington State, and their report would be invaluable to plan for the future and to attract investors.

When the report was completed in December 1959, it described the ski terrain in Alpine Meadows as:

> *A rare combination of high glacial valleys and cirques with a wide variety of open slopes and sparsely scattered clumps of fir, hemlock and pine. Almost no clearing will be needed. There are four distinct bowls descending from a high ridge, which maintains an elevation above 8,300 feet. The high ridge on the west breaks the wind, and the arêtes that descend to the floor of the valley offer many combinations of North, South and East slopes.*

After recommending where to place the lifts, the report continues, "The high valley floor of 1,690 feet from the base to the top of the main lift, combined with the unusual ridge formations of the four bowls, make possible some of the best skiing in the United States, as evidenced by written

opinions of experienced skiers." One of those "experienced skiers" was Willy Schaeffler, who had visited the area in both summer and winter in the three years preceding the Olympics. In a letter dated April 16, 1960, he expressed his enthusiasm for the area for the following reasons:

> *1. The skiing terrain that will be opened by one lift from the proposed lodge to Ward Peak alone is more varied and suited for all types of skiers than in any other area I know in the USA.*

> *2. Early and late even snow pack in the area indicates very little wind action. Ward Bowl is surrounded by high peaks, which are responsible for the wind protection and even snow.*

> *3. The terrain is ideally suited for the needs of modern ski teaching of all levels of skiers, including racers, since there is a vertical drop of almost 2,000 feet, and the area has almost unlimited possibilities for immediate or future development in the surrounding mountains—Scott Peak, Twin Peaks, etc.*

In closing, Schaeffler commented, "Over sixty million people were able to see the winter games on TV. My opinion is that the number of skiers will at least double in the next ten years."

Peter Klaussen also submitted a report in December 1959, noting that "Alpine Meadows has the finest terrain I have seen, has abundant snow of good consistency and has the variety to delight skiers of all abilities." At Reily's urging, Klaussen spelled out the advantages of installing a gondola lift up Ward Peak:

> *1. A tremendous boost to area publicity.*
> *2. Lift Alpine Meadows above competition.*
> *3. Stimulus to summer and spectator business.*
> *4. Novelty will attract skiers from all over the West.*
> *5. Fewer towers needed, can span avalanche danger.*
> *6. Attractive during adverse weather.*

By December 1959, Reily had ferried ski enthusiasts of all ages, abilities, interests and incomes to view his valley in winter and in summer, and from that roster he formed a board of directors for his proposed corporation that read like a who's-who of national skiing. C. Minot "Minny" Dole

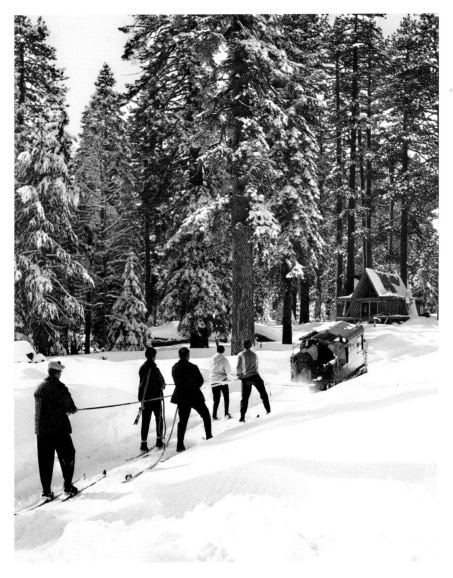

Weasel snow cat pulling skiers to Reily's cabin in Alpine Meadows. *Photograph by Donald E. Wolter.*

of Connecticut was the founder (1938) and national director (1940) of the National Ski Patrol System, a member of the 10th Mountain Division and author of the 1947 National Skiing Guide. Malcolm McLane of Concord, New Hampshire, was director of the National Ski Association (1957–60), chairman of the 1960 U.S. Olympic Ski Games Committee

and a founder of Wildcat Mountain Ski Area Corporation in Pinkham Notch, New Hampshire.

Friends from Southern California included Bob McCulloch of McCulloch chainsaw fame and John and Sally Hudson, part owners of Sporthaus Westwood in Los Angeles and Squaw Valley. Sierra Club member Bill Kimball and Bestor Robinson, former president of the Sierra Club, former vice-president of the National Ski Association and a member of many environmental and ski-related associations, had the respect of outdoor preservationists. Los Angeles and Bay Area lawyers, doctors and investment bankers rounded out the list. One thing they all had in common was that they loved to ski and they wanted Alpine Meadows to be a low-key "skier-owned and operated ski area."

Alpine Meadows of Tahoe, Inc. (AMOT) became a California corporation on December 4, 1959, with the stated purpose "to build and operate a winter ski and summer tourist resort in the adjoining valley south of Squaw Valley." The corporation had six months to raise $1.4 million in capital stock, at which time (August 27, 1960) funds would be released from Wells Fargo Bank and Reily's dream would be a reality.

## NIGHTMARE TO OLYMPIC DREAM

Four days before the Olympics were scheduled to begin, a warm Pacific storm blew over the Sierra, lashing the valley with rain and sleet. Alpine competitors, eager to run the downhill, couldn't inspect the course, and course setters worried that the five courses they had so carefully prepared would dissolve in the deluge. Wind gusted over one hundred miles per hour. Trees fell, taking power lines with them. Rock debris skimmed across the practice rinks. Organizers and officials huddled to discuss alternate plans. Legions of boot packers waited for commands, and snow safety patrolmen and women prepared for early morning treks to the highest peaks and ridges.

Wayne Poulsen looked with dismay at the parking lot on his land in the western end of the meadow. Months ago, when he learned that the planning committee was going to pave 130 acres for a parking lot, he convinced them that a better solution would be to compact the snow and mix in a layer of sawdust on top—a great idea, as long as the ground was frozen. Now, the day before thousands of cars would arrive for the opening ceremonies, the parking lot was thawing into 130 acres of mud.

On February 17, the night before the opening ceremonies, temperatures dropped and the parking lot froze. Rain turned to snow and covered the racecourses, swirled in gusts through the valley and obliterated the road. U.S. Vice President and Mrs. Nixon, unable to arrive by helicopter as planned, crept along with the masses in a stop-and-go slog of cars making their way into the valley to Blyth Arena, where they joined hundreds of hooded spectators groping their way through the blizzard to their seats in the ice arena.

At 1:00 p.m., just one hour behind schedule, with the athletes lined up outside in the storm, a drum roll performed by hundreds of California and Nevada high school bands signaled the raising of the flags of Greece, the United States and the 1960 Olympic Games. Then, the flags of thirty-one nations reached the top of their standards as the Olympic Band played "The Parade of the Olympians." The athletes followed their flagbearers into the arena and stood in groups under the vast ceiling as snow flew by outside.

While Prentis Hale, president of the Olympic Organizing Committee, made his welcoming speech and Vice President Nixon declared the games

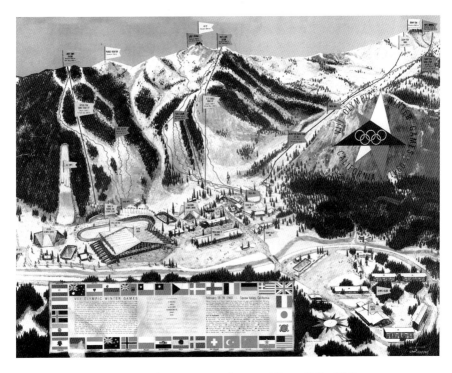

Map of 1960 Olympic events from program. *Courtesy of Squaw Valley Ski Corp.*

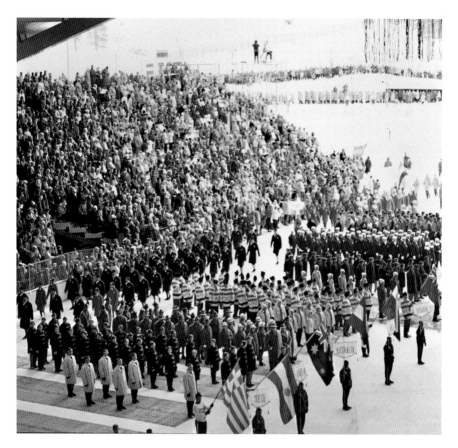

Opening ceremonies in Blyth Arena, 1960 Olympics. *Photograph by Bill Briner.*

open, all eyes looked up to Papoose Peak. The snow had stopped—the sky cleared, fireworks exploded and thousands of balloons and pigeons (doves of peace) rose up into a blue sky. Andrea Meade Lawrence, 1952 double gold medalist, skied down through the fresh powder carrying the Olympic torch and handed it to five-hundred-meter speed skating champion Kenneth Henry. After a lap around the outdoor rink, Henry climbed the steps to the urn at the Tower of Nations and lit the Olympic cauldron for the 1960 Winter Games. To this day, athletes and spectators ask themselves if legendary event master Walt Disney included weather control as part of his Olympic opening spectacle.

California's now notorious blind luck let the snow continue through the night, followed by a week of sunshine. During that now famous and much-chronicled week, athletes enjoyed the first and only winter

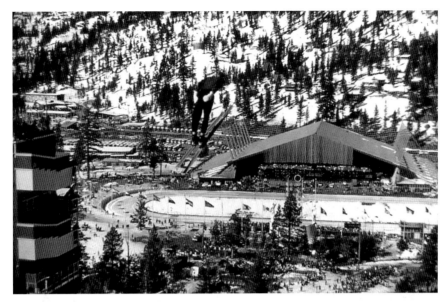

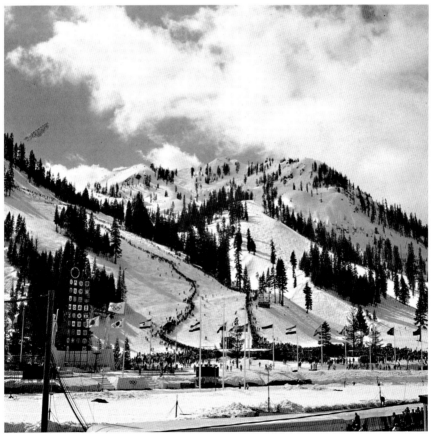

Olympics where they could walk or ski from racecourse to ski jumps to ice rinks and back to their own village. Only the cross-country and biathlon events were held outside of the valley. Spectators joined competitors on the mountains along the rails of practice arenas and inside Blyth Arena to cheer their comrades and teammates. By the end of the week, everyone was rooting for the plucky U.S. hockey team, who had defeated the mighty Russians and then—with helpful advice from the Russian coach and the vocal support of his team—won the gold medal in a grand finale match against Czechoslovakia.

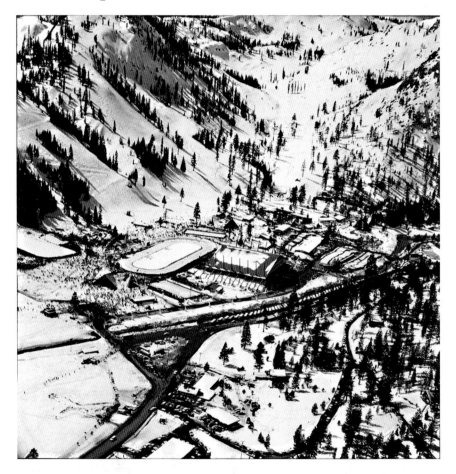

*Above*: Overview of Squaw Valley during the 1960 Olympics. *Photograph by Bill Briner.*

*Opposite, top*: Blyth Arena jumper. *Photograph by Richard Hansen, Squaw Valley Ski Corp.*

*Opposite, bottom*: Men's giant slalom on KT-22, exhibition run, 1960 Olympics. *Photograph by Bill Briner.*

During the games, IOC members stayed at the Squaw Valley Inn (now Plump Jack's), where fresh seafood and California produce flown in daily from San Francisco were elegantly prepared and accompanied by California's finest wines. Walt Disney's nightly shows in the athletes' center united coaches and athletes from all nations and (unbeknownst to officials) attracted a number of locals over the well-trodden trails through the forest behind the complex. With no lodging for the public in the valley, every bed, couch and available floor space was occupied in the one hundred ski chalets located along the road into the valley. Newly opened motels in the nearby towns of Truckee and Tahoe City sold out at $25 per person a night.

Declared "the best Winter Olympics ever" (an opinion still held by athletes, spectators and officials), Squaw Valley will long be remembered for its many firsts: the first time a woman (gold medal skater Carol Heiss) took the Olympic oath, the first women to compete in speed skating, the first Olympic biathlon, the first time the games were televised on one network (CBS) with instant replay, the first time results and scores (including speed, distance and style) were electronically tabulated (IBM) and the first time metal skis were used—ensuring that a nation (France) other than Austria dominated the men's downhill.

## AFTER THE GAMES

After the closing ceremonies on February 28, loyal clients from pre-Olympic Squaw returned to the lodge, the slopes and the Beer Garden. Squaw's devoted band of locals reclaimed their valley, and John Reily reclaimed his restaurant atop KT-22, enticing many of Squaw's new devotees up the KT lift to his Cornice Restaurant, where they could look down on Alpine Meadows—un-skied and undeveloped—and contemplate owning a part of it.

In the spring of 1959, Peter Klaussen invited his friend David Tucker to join him and Reily on a run from the Cornice down into Alpine, where a snow cat would meet them and take them out to the road. On learning that Tucker was a recent architectural graduate, Reily invited him to create a master plan for the area with roads, bridges and a day lodge. After additional visits, Tucker's plan became his graduate thesis.

On one of these snow cat tours, Reily invited the young architect to join him in the cab to discuss the proposed lodge. "I was so excited," Tucker said. "I thought Reily was asking me to design the lodge. What a great way to begin my career. Then he told me I would have to finance it."

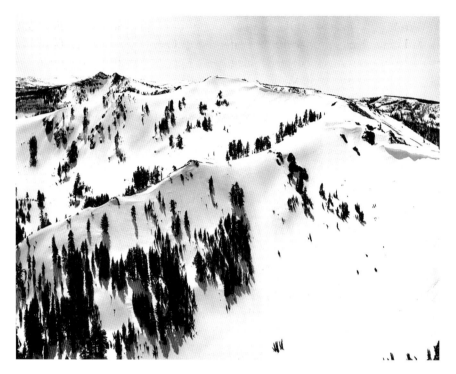

View of Ward Peak, Twin Peaks and Lake Tahoe from Squaw. *Photograph by Donald E. Wolter.*

On February 26, two days before the games ended, the California commissioner of corporations issued a permit for Alpine Meadows of Tahoe, Inc. to sell 140,000 shares of common stock to the public at $10 a share in units of 100 shares. They had until August 26 to raise the capital investment of $1.4 million. With lots in Alpine Estates and lift privileges for the first five years included, Reily's dream of launching a ski area "owned by skiers" was nearing reality.

A prospectus described the stock offering and the intent "to build and operate a winter ski and summer tourist resort in the adjoining valley south of Squaw Valley." It included the 1959 feasibility report by John Graham and Company, in which they proposed initial facilities of one chairlift, two surface lifts and "an enclosed gondola" to the top of Ward Peak. The board of directors, after weighing the costs of installation versus attraction to non-skier tourists and recognizing that a double chairlift would transport more skiers per hour on weekends and holidays than a gondola, decided to wait and see if skier demand exceeded lift capacity over the next two years. The gondola was moved into Phase II.

Like most ski areas, the company anticipated that its revenue would be derived from the "sale of tickets to skiers and tourists for riding the lifts during the winter operating season, the sale of tickets to tourists for riding the main aerial lift during summer operating season, the sale of ski equipment, clothes and souvenirs, ski rentals and repairs, ski school instruction, and the sale of food." It went on to say that if the company found any of these activities to be more efficiently run by concessionaires that it would lease them for a fixed amount or a percentage. The prospectus states, "The Company does not plan to construct any housing facilities because of the availability of ample housing around Lake Tahoe."

# Over the Mountains and through the Woods

Spring skiing was at its corn-snow best in March when Reily organized a helicopter tour from the top of KT to the top of Ward Peak for the board of directors, press and assorted ski luminaries. Peter Klaussen and Norm Wilson preceded the party, flying in from Deer Park Lodge (now River Ranch) to the base of Ward Peak, where they dropped off food for a barbecue and then headed to the summit. After a photo shoot with Don Wolter, they skied down the ridge, checking for avalanche hazards.

Included in the group were Olympic course designer Willy Schaeffler and Tom Corcoran, four-time U.S. Alpine ski champion and, at the time, the highest-placing male U.S. Ski Team member, after finishing fourth in the Giant Slalom at Squaw Valley. He listened to Reily's plans and agreed on the virtues of the site. Aware that Corcoran understood the business of skiing and observing a keen interest that might lead to a future in ski-area development, he asked Corcoran if he would consider the position of general manager. "John, if I ever manage a ski area, it will be my own," was his prophetic answer. Six years later, Corcoran acquired Waterville Valley Ski Area in New Hampshire, which he owned and managed until 1999.

During the summer months, Reily established a sales office in Deer Park Lodge at the entrance to Alpine Meadows. From there, he sent prospective investors two miles farther up a dirt road on the south side of the valley to the site of the old Deer Park Springs Hotel, where they could ride in a jeep to the base of the ski area. These tours were often enhanced by an elaborate picnic, which was hosted by Reily and attended by Art Linkletter, John and

Sally Hudson, board members and enthusiastic supporters from Tahoe City, Los Angeles and San Francisco.

Lowell Northrop, who had installed the original Siberia ski lift for Cushing at Squaw Valley in 1958 and the KT lift in 1959, had been hired by Reily to build Alpine's lifts. Having managed all eight of Squaw's lifts before, during and after the 1960 Olympics for the state of California, his experience and devotion to the mountain environment would be an important asset.

With funds growing slowly, Northrop and Klaussen were relegated to road and lift surveying. An existing road from Highway 89 up the south side of the valley to the old Deer Park Springs Hotel could be extended up to the base area, but after further explorations, they decided it would be too steep and went looking on the other side. After finding a spot to lay a bridge over Bear Creek, they began laying out the future road on the north side, convinced that avalanches could be controlled from the ridge above.

Both men were compensated for their work with the promise of a lot in the newly developed area. Reily gave Northrop six acres of land. Later, on learning that Reily had promised his investors more lots than he possessed, Northrop had to sell lots from his six acres. He and his wife, Barbara, Alpine's first fulltime residents, built their home in 1964. They raised three daughters while he continued to work on roads in the area and build ski lifts at Boreal Ridge, Northstar and other North American ski sites well into his eighties. A third-generation Californian, Lowell died April 22, 2008, at the age of eighty-nine. Barbara continues to live in their home by Bear Creek.

# UP AT THE CORNICE

High above Alpine Meadows, the Cornice Restaurant was serving its famous "Alpenburgers" to summer visitors brave enough to ride the KT-22 lift to the top. When Peter Klaussen wasn't exploring Alpine in the World War II jeep Reily had loaned him, he was assisting his wife, Joan, in setting up and running the restaurant. "The KT lift was the only one used for summer tourists," writes Klaussen in a memoir for his children. "Most of our summer patrons wore flip-flops and were scared to death by the chairlift ride. Many offered us princely sums to get them off the mountain in some other way. Alas, we couldn't help them unless they chose to walk down—and many did just that." Efforts to sell souvenirs to patrons were severely impacted by the

Looking down KT-22. *Photograph by Tom Lippert.*

frightening prospect of having to ride the lift down. "Joan held hands and gave out aspirin," Klaussen wrote.

David Tucker, who also worked at the restaurant, recalls riding up the lift with Cushing one summer day. When the lift stopped in a particularly long span, high above a rocky chasm, and the chair began to fall and rise in deep, slow-motion ups and downs, David observed Cushing holding onto his chair with a white-knuckle death grip. He asked Cushing why there was such a huge span at this point. Cushing told him that that there once had been a tower in this span but that it was carried away in an avalanche and never replaced. The response was not reassuring.

Because they had no running water and intermittent electricity ("borrowed" by connecting an extension cord to a generator in the lift shack), they had no permit to cook or wash dishes onsite. Joan Klaussen prepared soup and sandwiches in her kitchen at home and then transported everything up the lift early in the morning: clean dishes and utensils, fresh wholegrain bread and donuts from a bakery in Truckee, beer and wine, soft drinks, soups, sandwiches, hamburgers and hot dogs ready for grilling on a raised fire-pit they also used for heat. Dirty dishes and garbage were transported down the lift at night.

Reily purchased a stainless steel kitchen for the restaurant at a bargain price and sent it up the lift to be installed by Tucker and Klaussen, but they couldn't use it, so they stored it under the building, where it lay forever corroding.

Throughout that summer and the following winter, Reily used his restaurant to entertain guests and to pitch Alpine Meadows. Together with his wife, Winnie, and son John, Reily held investor parties that challenged the ingenuity and culinary skills of the Klaussens.

At one of these events, Tucker recalls that after baking potatoes in the Klaussens' oven and transferring them up to the restaurant, they arrived "cooked on the outside, raw on the inside." He also remembers grilling eight-inch New York Strip steaks for the guests, with Reily burning his own steak "to a 3-inch piece of leather." Luckily, most of those parties included enough wine and liquor to mitigate the quality of the food and fortify guests for the ride down in the dark.

Cushing and Reily often met at Reily's aerie overlooking their respective ski areas to discuss the pros and cons of a lift on the backside of KT. Reily, concerned that his customers would have to ski back into Squaw, opposed the idea. Cushing, with the desire to increase his parking capacity, liked the idea. They both agreed that the two areas could be joined in a "ski circus from Sugar Bowl to Lake Tahoe."

Before the end of August, a forest fire that had grown to disastrous proportions along Interstate 80 closed all roads to North Lake Tahoe and shut off power to the area. The Cornice was forced to close until winter.

Hoping to attract more investors in his area, Reily offered ten years of lift privileges to investors of $5,000 or more. In spite of his lavish picnics, barbecues at the Cornice, jeep tours to Alpine and hundreds of mailings and meetings, August 28 arrived with AMOT, Inc. short on funds but Reily still long on hope.

## Altered Dream for Alpine

Over the summer months, AMOT's engineers and consultants revised their estimate for the first year of operation to fifty-two thousand skiers (about 15 percent of Lake Tahoe-bound skiers) and calculated that the sale of lift tickets at Alpine Meadows would produce revenue of $200,000—a sufficient amount to reduce initial financing from $1.4 million to $850,000.

With what seemed like a more achievable goal, Reily launched an even more vigorous campaign to raise funds. "Show Me" meetings were scheduled for January in Sacramento and Los Angeles. According to a newsletter published by AMOT in January 1961, "Los Angeles skiers don't seem to mind traveling long distances for good snow conditions. They've long been going to Sun Valley, Aspen and other far away points. Forty Los Angelinos skied Squaw last weekend."

Warren Miller's film *By Helicopter to Alpine Meadows* was featured at many of these gatherings. A newly elected member of the board of directors and an enthusiastic supporter, Miller states in the abovementioned newsletter that "the increase in skiing of recent years has been 10 percent to 15 percent per year, but this year it will be 25 to 30 percent." Miller cites that in St. Paul, the audience for his latest film increased from three thousand to over seven thousand, proving a marked interest in skiing across the country.

Letters from stockholders went out to friends and ski clubs, inviting them to investor briefings in Los Angeles and San Francisco and encouraging them to visit Alpine in winter on a "ski-joring weekend." John Hudson wrote in a letter to friends in the ski industry and to his many customers in Los Angeles and Squaw Valley, "Having had a home and operated a branch store in Squaw Valley for the last eight years, I have become aware

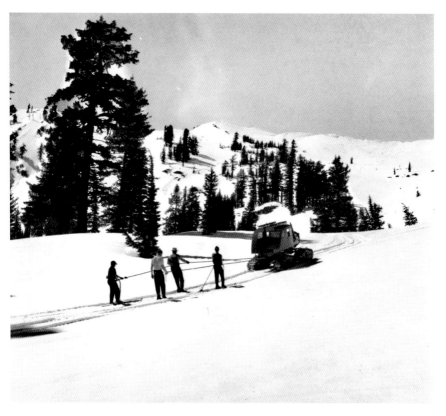

Reily pulling skiers behind the weasel into Alpine Meadows. *Photograph by Donald E. Wolter.*

of the number of new skiers and the need for new lifts to handle them."
Encouraging them to attend a "kickoff meeting" in Los Angeles, he goes
on to say, "I have become personally interested in Alpine for a variety of
reasons and have sold my house in Squaw Valley and plan to build in the
new area."

Winter arrived with plenty of snow in December for weekend ski-joring
trips into Alpine. Klaussen described the activity in his diary:

> *I'd meet a group at Deer Springs Lodge, pack as many as possible into the
> weasel and pull the rest on skis hanging onto ropes dragged behind. We'd
> stop halfway at Reily's cabin to transfer them to his Thiokol Snow Cat,
> which was powerful enough for the steeper rise and deeper snowpack up to
> the base area. Reily would meet the group, give them a good sales talk and
> sometimes join us.*

Those discouraged by the long haul across flat terrain or seeking the thrill of skiing into Alpine from Squaw could ski from the top of KT or Papoose down to the road and hitch a ride on the weasel to the base area in Alpine or out to Powder Bowl. More experienced skiers could reach the bowls on Ward Peak from the top of the tram, KT or Squaw #2 lifts by crossing Five Lakes, staying as high as possible and following a long traverse.

It was during one of these trips that my soon-to-be husband and I first saw that virgin valley, skied down into it and longed to own a part of it. On the way, we stopped on a rocky outcrop above the proposed road and looked up at the mountains forming a high protective ridge that seemed to hold the small valley in a welcoming embrace—something more intimate than Squaw's wide-open meadow at the foot of the mountains. "This is where I would build a house," I thought. Later, when we joined a group of skiers at Reily's A-frame cottage for wine, cheese fondue and a sales talk, I learned that Reily had already claimed that site.

While Reily continued his sales efforts on mountain forays, at sales meetings and in the press, Klaussen and Northrop conferred on where to locate towers for the Heron lift and what runs needed to be cleared for the two Poma lifts. They interviewed contractors and met with engineers and county officials to discuss the lodge, lifts and the road into the area.

At the end of March, Reily sent a letter to his directors and stockholders urging them to contact "friends and prospects who have procrastinated or must arrange financing" to subscribe before April 10, 1961, when they hoped to reach their goal of $850,000 and the funds would be released in time for summer construction.

After two years and many dollars spent in relentless pursuit of his dream, Reily was well short of his goal, and in May, he wrote another letter to subscribers, informing them that they could cash out, remain as a stockholder in AMOT, Inc. or upgrade to a new plan to raise $600,000 by the sale of 120 units of five hundred shares at $10 a share. This was Alpine's last hope of becoming a ski area.

The first 130 individuals to subscribe to this plan—at five hundred shares each (or more)—would become members of the Bear Creek Association and have the right to choose a lot within eighty-five acres of land leased from Southern Pacific Land Company just over a mile from the future ski area. Larry Metcalf, president, immediately sent a letter out inviting members to join him and directors Byron Nishkian and Bill Evers in this new effort to get Alpine up and skiing.

In a letter to "Alpine Meadows Enthusiasts." Metcalf wrote, "After matters of lot-size, type of allowable dwelling, site, road location, etc. have been determined, members will be given the opportunity to sell a lot to which they will receive a fifty-year sub-lease. Funds for engineering, roads, water, etc. will be raised by members." With plans for tennis courts and a pond for swimming, this was an attractive offer to Bay Area families familiar with the camaraderie of home ownership in Sugar Bowl, the winter watering hole for generations of San Francisco skiers.

The California commissioner of corporations approved the sale of seventy thousand shares. A new prospectus was released on June 12, and the checks rolled in. While waiting for funds to be released in late July, Northrop kept busy grading the future road and clearing sites for lift towers. Assuming there would be hard work ahead, he hired two German ski instructors, Hans Burkhart and Fritz Frey, to dig the holes for the lift towers.

Larry Metcalf and his friends in the Bear Creek Association invested enough to put AMOT over the top, and the funds were released in late July. General manager Klaussen, Northrop and their crew went into high gear, clearing previously marked trails, grading the parking lot and getting lifts up and running for a December opening date. Sausalito architect Fred Coolidge, who had agreed to design, build and finance the lodge, received a bid from Ray Johnson for $110,000, and construction was under way.

Bear Creek Association, now the majority stock holder, voted as a block to elect Byron Nishkian president of AMOT. An active skier in Yosemite since 1931, Nishkian was involved in skiing on many levels—as past president of the Far West Ski Association, vice-president of the National Ski Association and a member of the Events Committee for the 1960 Olympics. Nishkian and his Bear Creek Associates now controlled the ski area. Reily remained chairman of the board but had no control over the future of Alpine Meadows. His dream, at last, was realized—but not by him.

*Chapter 5*

# THE SIXTIES

## FIRST TRACKS AT ALPINE MEADOWS

Byron Nishkian went right to work. First, he brought his old Yosemite friend and ski-meister Luggi Foeger out of retirement to run the ski school and promised that Luggi's wife, Helen, would run the ski shop. He hired Tim Sullivan, who had worked for the USOC in Squaw as general manager. Peter Klaussen remained to manage mountain operations.

In late August, Nishkian decided to lower the cost of the lodge construction by using engineers from his engineering firm and by utilizing less expensive materials, so he sent Coolidge back to the drawing board to redesign accordingly. With only two months left to build, construction commenced on a "time and material" basis instead of a fixed price bid, resulting (according to Klaussen) in a more expensive lodge that was still under construction when Alpine Meadows opened on December 28, 1961.

With or without a lodge, families loved it—riding Chair One to the top of Ward Peak and descending on a variety of runs with differing terrain, always ending up in front of the lodge. Ski instructors loved it for its quantity and quality of intermediate terrain. Locals loved it because Lake Tahoe Ski Club, one of the oldest ski clubs in the country and whose membership included North Tahoe's oldest families, had a place to train and hold races. Stockholders loved it because they owned it. It was their own ski area, where their families and friends enjoyed their favorite sport in a magnificent setting and they controlled development. Nobody liked

Alpine Meadows lodge. *Photograph by Donald E. Wolter.*

the road—three miles of heavy mud, frozen ruts or slippery snow—but that would soon be fixed.

Peter Klaussen's position managing mountain operations and hiring, training and directing his employees would inevitably come into question. Hired by Reily (who knew how to promote a ski area but not how to run one) and now working for Nishkian (who did know how to run one—or thought he did), Klaussen found himself in a difficult position. Nishkian was more inclined to turn to his trusted friend Luggi for advice than to Klaussen. Working mostly outdoors and on the mountain, Klaussen managed to remain fairly independent from the daily decisions made in the offices of AMOT—until one day in March when a heavy snowstorm battered the area for a week, closing roads over the summit and ski areas, including Squaw Valley. Alpine, however, remained open.

That morning (as they did every morning), six of Klaussen's patrolmen went out before dawn to check the area for avalanches. As they rode up the lift, they threw charges to test the snow pack. At the top, they split into three pairs and set off to assigned areas, each man carrying fuse lighters and six

Larry and Sue Metcalf and children. *Photograph by Donald E. Wolter.*

four-pound hand charges with detonation caps taped on. One team skied along the cornice that hangs above Wolverine, Beaver and Estelle Bowls, flinging charges over the edge and then listening for the muffled "karumph" of an avalanche. Another team did the same along the crest of Alpine Bowl to Ward Peak and down into Weasel Pass, while the third team took the easy route down the middle. After one more trip up the lift to ski check the

Virginia and Phil Rogers and family at Alpine. *Photograph by Donald E. Wolter.*

bowls and faces, the men pronounced it safe to open for the public. Then the machines would come out to groom the runs, sometimes driving all night to keep up with the storm.

Normally, after snow safety work and mountain grooming, Klaussen's crew went to work clearing the area around the lodge, which included the ski school meeting place. Klaussen, who was in Reno attending the birth of a son during the storm, knew that his men were exhausted from working sixteen-hour days, and he was aware that Donner Summit was still closed to traffic, so when the storm abated, he sent them home to rest.

When Luggi returned, he found his signs covered with snow and his meeting place unplowed. He complained to the only man around, the lift operations manager, who (later pleading exhaustion in having worked fourteen hours) snapped back in defense. Luggi fired him on the spot.

Klaussen, making a case for long hours without a break, asked to have his man reinstated and offered an impossible alternative: "If he goes, I go."

No longer possessing the authority to manage and direct his employees, Peter Klaussen ended his six-year involvement with Alpine Meadows.

## SKI SCHOOL STORIES

Luggi's reputation as a devoted ski school director attracted amiable and able instructors from Austria, Australia and the United States. All of them shared his enthusiasm for instilling a love of skiing through increased skills. As stockholders' children and many of their wives advanced through Luggi's ski school, they formed lasting friendships with instructors and a loyalty to Alpine that would endure through future generations.

Babette Hauiesen loved the snow—living in it, skiing, competing and sharing her passion for the sport by teaching others how to ski. While working at Sugar Bowl in the early 1950s, Bill Klein recognized her athletic talent and coached her to many victories, including the prestigious Silver Belt Race in 1955. After placing in the top ten at the 1956 Olympic tryouts at Stowe, Vermont, Hauiesen broke her leg and ankle, ending all hopes of a racing career. However, a new career was waiting for her in Austria, where she took an instructor's course in St. Christophe and joined the ski school in St. Anton.

By 1960, she was back in Tahoe, carrying the Olympic torch in the relay (skiing on barrel staves) to Squaw Valley. When Alpine opened the following year, Hauiesen applied for a teaching job, only to learn that Luggi didn't hire women. Although she was probably more qualified than most of the men, Luggi wasn't interested. Persistence, charm and ability finally won out, and for the next sixteen years, Hauiesen encouraged and inspired generations of skiers at Alpine and later at Northstar with her "can-do/this-is-fun" approach to the sport. In 1995, *Skiing* magazine recognized Hauiesen as one of the "Top One Hundred" ski instructors in the United States.

Werner Schuster left his home in Bavaria as a teenager, taught skiing to customers of his father's ski shop in Munich and then ventured across the Atlantic to Canada, where he was a popular instructor at Gray Rocks Resort in the Laurentians. When a friend (Tom Adams) and fellow ski instructor told him that Luggi Foeger was looking for an assistant ski school director at a new ski area in California, Schuster headed west, arriving at Alpine

Babette Hauiesen and class, including "Hoss" Cartwright from *Bonanza*. *Photograph by Donald E. Wolter.*

Meadows in December 1963. From the beginning, Schuster showed interest and abilities beyond ski instruction. An astute observer of the total ski scene, from management to employees to the skiing public, Schuster looked at the big picture. Marketing and publicity were in his DNA.

When Luggi left Alpine in 1967 to lay out a new ski area at Incline Village, Nevada, Schuster took over the ski school and, consequently, marketing of the area. As ski school director, he did not embrace any one of the many national techniques currently being taught—French at Squaw, Austrian at Heavenly and Alpine or Swiss at Mammoth. Instead, he hired instructors from different countries, and with plenty of input and analysis from all parties, blended them all into an "American Technique—one technique presented with foreign accents," as he wrote in his "Recollections of Skiing and Winter Tourism at Tahoe." Inevitably, Alpine's popular and respected ski school director would be called upon to participate in regional, national and international ski instructor organizations, serving as president both regionally and nationally.

From ski school instructor to director to marketing vice-president to executive vice-president for business development at Powdr Corporation

Werner Schuster in form. *Photograph by Donald E. Wolter.*

(the Utah corporation that acquired AMOT in 1995), Werner Schuster's contributions to the ski experience at Alpine Meadows over forty years were significant. As quoted in Robert Frohlich's *Mountain Dreamers*, when he left the slopes for the corporate side of skiing, Schuster said:

> *I never forget what we're selling. It's not just a lift ticket, but an experience, an emotional experience, a family experience. If you can get that message across to people who have never even experienced snow-*

*sport, then skiing will always have a competitive advantage over other choices of recreation. It is truly a lifestyle we can sell sincerely, because it's the one we've opted for.*

## MANAGING THE MOGULS

When the ski area closed after their first year of operation in April 1961, revenue far exceeded expectations. With high marks for good snow, interesting terrain and competent and friendly employees, Alpine Meadows had established a reputation as one of the finest new ski areas in the West.

Encouraged by their success at the end of their first season, AMOT sent out a prospectus the following year to its three hundred shareholders to raise funds to triple the size of the parking lot, expand the lodge and lease a Riblet chair to be installed slightly southeast and parallel to Chair One, with its

AMOT, Inc.'s board of directors. *Left to right*: Byron Nishkian, Bill Evers, John Reily and Larry Metcalf. *Photograph by Donald E. Wolter.*

terminal on a ridge about a third of the way down from the top of Chair One. Chair Two, its intermediate runs sheltered from the elements, could operate in all weather conditions. Remaining revenue from the 1961–62 season was spent paving that muddy, slippery road, expanding the parking and adding another Poma lift.

Unfortunately, Mother Nature decided to teach Alpine a lesson in the realities of running a ski area, that lesson being that one season's snowy success can be wiped out by another's snowless catastrophe. This was the case the following winter of 1962–63, when measurable amounts of snow didn't fall until late February. It was the driest winter in one hundred years.

In a letter to stockholders, Nishkian wrote, "Through March 3rd, only eight of the seventy-five normally skiable days were reasonably productive, and on none of these were conditions good enough to draw more than half the attendance of a reasonably good day last season. Revenue has been reduced over 60 percent." Nishkian's letter appealed to stockholders to "protect the value of your present equity" and "assure the continued development of Alpine Meadows" by subscribing to additional shares in AMOT, Inc.

Once again, Larry Metcalf and others answered the appeal, and the next winter (1963–64) provided abundant snowfall for thousands of skiers who, after skiing Alpine's wide-open bowls, steep ridges, chutes and secret gullies from November to May, became loyal devotees of Alpine's modest mystique.

## LIFT STORIES

Throughout the '60s, both Alpine Meadows and Squaw Valley expanded their lift capacity. Alpine added Chair 3 (3,880 feet) in 1964, south of the lodge up Weasel Summit. Described in their brochure as a place where "not-so-expert skiers can enjoy their first lessons apart from the experts and Lodge sundeck kibitzers," the gentle runs were laid out by Luggi.

Two new Poma Lifts on Scott Peak, east and slightly higher than the terminal of Chair 3, gave access to Ward Creek Basin below Twin Peaks on the backside of Ward Peak, where a new Sherwood Forest lift (4,000 feet, 1,100 vertical) carried skiers up the south-facing slope back to Alpine Meadows.

Expert skiers delighted in a more adventurous route, especially in the spring, when the tiny figures of skiers could be seen crossing "the high traverse" from Chair One on Ward Peak to a saddle. There they would

High traverse along the top of Alpine to Twin Peaks. *Photograph by Donald E. Wolter.*

pause to look east at big blue Lake Tahoe, nestled in her snow-white winter bed, before disappearing from the horizon down into the wide open bowls and timbered slopes of Ward Creek Basin.

With two more chairlifts (Scott and Yellow) and connecting surface lifts adding more terrain between Scott Peak and Sherwood Forest, Alpine Meadows had quadrupled its ski terrain to six thousand acres. At the end of the 1965–66 season, Alpine was named the "Most Outstanding Ski Area" by the Far West Ski Association.

While Alpine added six lifts and a neighboring valley to its domain, Cushing, who always claimed he was "in the uphill transportation business," added ten lifts in Squaw Valley.

First was Gold Coast in 1962, spanning a gentle slope at mid-mountain, where, at 8,200 feet, beginners benefitted from good snow that lasted well into spring and guaranteed a longer season in light snow years. The Gold Coast lift also accessed Shirley Lakes, where a lift built in 1964 brought skiers back up to Gold Coast. Emigrant and East Broadway chairlifts further expanded the mid-mountain area.

Contemplating Ward Valley, with Twin Peaks in the background. *Photograph by Donald E. Wolter.*

Two years later, a high-capacity double chair replaced the iconic twelve-passenger Jigback tram on Headwall. The twelve-person lift was used in the 1960s only by ski patrol, but gone were the days when one shared the North Bowl, South Bowl and many secret slots off of Headwall with only eleven other skiers.

The Exhibition lift at the bottom of KT, installed in 1967, soon lived up to its name playing center stage for competitive events from World Cup and Pro Races to Nastar and local team races. Parents watched their children (in junior races), children watched their parents (in masters races) and teammates cheered from the base of the mountain as racers schussed through the finish gate at the bottom of Little KT in front of the lodge.

In 1968, four more lifts were added, including a 7,500-foot tram. "Alex called it a cable car, although a cable car is pulled by an underground cable on a street. Alex thought nobody out west would know what a tram was, so he decided to call it a cable car," said Hans Burkhart, the man who's been behind, under and on top of every lift in Squaw since his arrival in 1962.

# HANS BURKHART: A MAN OF MANY SKI LIFTS

Hans Burkhart grew up in a farming community in Germany. There he worked at his family's shop on farm machinery and intended on going to engineering school. However, he left his native land in 1958 for the National Park at Banff, where he was hired by a Swiss firm to work on Canada's first gondola and the first bi-cable gondola in North America. After surveying the mountain and selecting a site, Burkhart and team cut a track and installed a temporary lift for construction, which was followed by upper and lower terminals, lift towers and finally, the cables and gondolas. All of the equipment was shipped from Switzerland.

After the Sulphur Mountain Gondola opened in Banff on July 18, 1959, Burkhart decided not to return to Europe as planned. What he really wanted to do was go to the United States and build ski lifts, but with no jobs available, he went to Aspen to teach skiing with Stein Erickson. At the end of the 1961 ski season, he headed west to seek his fortune in California's northern Sierra Nevada, where a post-Olympic boom promised the possibility of new ski area developments.

Burkhart and his friend Fritz Frey arrived in Alpine Meadows at the end of the summer, just before Bear Creek Association came to the financial rescue of the ski area. With an opening date set for Christmas that year, Lowell Northrop and Peter Klaussen were eager to get the lifts up and running.

Northrop hired the two young men to dig twenty holes for the lift towers up Ward Peak. At $160 per hole, they thought that was pretty good pay and set to work digging a hole a day by hand. Lowell first had them dig a hole three feet wide and four feet deep so that both of them could fit inside with their shovels. Then one would dig down to six feet, throwing the buckets up to his partner, who would then throw the dirt over the top. Working long hours, they often slept in their Volkswagen Bug by the site and showered down at the Deer Park Lodge. They completed the job in record time.

After another winter teaching skiing in Aspen, Burkhart returned to California in the spring of 1962 to work on the lifts in Squaw. In a publication celebrating Squaw Valley's fiftieth anniversary, Nancy Cushing writes:

> *Cushing needed someone to oversee maintenance of that first gondola, and when he asked for a recommendation of a man for the job, the manufacturer pointed up the hill to Burkhart, who was hanging upside down over a cliff with a drill in his hand.*

Burkhart claims that at the end of the 1962 ski season in Aspen, he had a choice to work on a gondola in Park City or Squaw. He chose Squaw. In either case, the fact that the manufacturer of the gondola (Pohlig-Heckel-Bleichert, a leader in European lift design) was German, the plans were all in German and the engineers who came to install it spoke only German ensured Burkhart's position as project manager for Squaw's first gondola. Thus began a forty-year relationship fraught with contention, love, hate, lawsuits and mutual respect. After finishing the project in 1964, Burkhart told Cushing he would leave Squaw the next year to build a tram in Albuquerque, New Mexico.

"What?" Cushing exclaimed. "You can't leave. We'll build a tram here."

"You don't have a mountain for a tram," Burkhart replied. "Where would you build it?"

Cushing pointed at the wall of rocks directly in front of the lodge and said, "We'll put it there. We'll go right over those rocks."

If Burkhart and Cushing shared anything, it was a passion for beating the odds and proving that sheer will can overcome all obstacles (remember the Olympics). And so it was that Burkhart, Cushing and a group of engineers and architects set out for Europe in 1966 to travel through the Alps and observe every ski lift yet invented that might go up and over those rocks in Squaw Valley. They chose Garaventa, a Swiss firm with thirty years' experience building trams in the Alps and around the world. The following summer, Garaventa and his engineers came to Squaw to assess where and how the tram would be built. They then returned to Switzerland to design, manufacture and pre-assemble nine hundred tons of equipment to be transported by barge down the Rhine River and loaded onto three ships bound for San Francisco and up the Sacramento River to the capital city.

According to Nancy Cushing in Squaw's fiftieth anniversary publication, "Burkhart and his team worked seven days a week, twelve to fifteen hours a day, to complete the project in time for the 1968 Christmas opening." At the last minute, when a pesky state inspector claimed he would not issue a permit for the tram to open because of a minor railing issue, Burkhart pleaded, "Just tell me what it is. I'll stay up all night and fix it." Those words pretty much defined Burkhart's career in Squaw Valley, as Cushing often depended on Burkhart to "just fix it."

At a gala opening party, Cushing and his guests, swathed in furs coats, christened the "cable cars" with champagne and then rode the "the world's largest aerial tramway" to the top at High Camp.

Unloading the tram in Sacramento. *Courtesy of Squaw Valley Ski Corp.*

Tram building under construction. *Courtesy of Squaw Valley Ski Corp.*

Uphill transportation at work (tram and gondola). *Courtesy of Squaw Valley Ski Corp.*

Burkhart, who prided himself on finishing all of his projects on time and on or under budget, would go on to supervise the construction of trams in Snowbird, Mount Bachelor, Jackson Hole and Vancouver, but the Squaw Valley tram would always be his proudest achievement.

## Leave It to Reily

Just as John Reily once looked from Squaw Valley down into Alpine Meadows and vowed he would build a ski area there, he now looked from Alpine Meadows down into Twin Peaks, vowing he would build one there.

Since the day he first looked across those mountains, Reily had imagined skiing from Squaw Valley to Lake Tahoe and perhaps all the way from Sugar Bowl. Having skied from resort to resort in Europe, he thought that a European-style "Ski Circus"—where resorts are linked by ski lifts and skiers ski from their chalet to a lift without the need of a car—was possible in the northern Sierra.

During one of his European ski trips, Reily observed that in modern resorts like Verbier in Switzerland and Courcheval in France, the lifts, which were built before the town (not the other way around, as is more common in Europe), were laid out above and below the houses. With this concept in mind, he returned to California with the idea of a mountain country club with surface lifts transporting skiers between their homes and the base lifts. His lifelong conviction that everyone needs a vacation home in the mountains took on new purpose as he plotted, planned and promoted Twin Peaks Ski and Golf Club— a real estate development on 480 acres of land between Alpine Meadows and the West Shore of Lake Tahoe. With access to all the lifts in Alpine Meadows, who wouldn't want to have a home in this wide open valley where one could ski from the top of Ward Peak right down to his kitchen door?

At Reily's request, John Graham and Co. returned to Alpine Meadows in 1962 to assess the potential for expanded facilities into the neighboring Twin Peaks basin. The project engineers identified twenty possible lift locations, including a tram to the top of Ward Peak, and they noted the desirability of a new development in close proximity to Alpine, Squaw and Lake Tahoe.

Once again, Willy Schaeffler, U.S. director of ski events at the 1960 Winter Olympics and an internationally respected ski area consultant, supported Reily's plan with his expert opinion. Schaeffler had explored the area in both summer and winter during the three years prior to the Olympics, and when he skied into the area from Alpine Meadows, he said:

> *I am very impressed with the tremendous size of the two major bowls between Ward Peak and Grouse Rock, as well as Grouse Rock and Twin Peaks. The actual size of the two bowls together and the future development potential of this whole area is twice the size of Alpine Meadows and one and one half times the size of Squaw Valley.*

Monty Atwater, a Squaw Valley resident, avalanche expert and renowned ski area consultant, described the terrain below Grouse Rock as having "primarily a northern exposure on partly open and partly timbered slopes with expert to intermediate terrain. The skiing here will be of the highest quality in the area."

Eager to share (and to sell) his dream to like-minded investors, Reily appealed to every skier's inner explorer with organized ski tours from the top of Chair One down to a meadow below Twin Peaks. After exalting in the scenery and the thrill of picking one's own path through un-skied territory, happy skiers piled in to a weasel waiting to carry them back up to Weasel

Looking into Ward Creek Basin with Twin Peaks on the horizon. *Photograph by Donald E. Wolter.*

Pass, where they skied back to the Alpine Meadows Lodge. Reily advertised his tours with the admonition, "The trips are limited to proficient skiers in good physical condition, who, whether they invest or not, get a couple of hours of good exercise." That statement alone was as good a sales pitch as any.

Kit Carson White, a ski writer for the *San Francisco Examiner*, and his wife, Vi, were among the first people to be pulled across the Squaw Valley Meadows by Wayne Poulsen in 1948. Twelve years later, they joined John Reily and members of the press on a helicopter tour into undeveloped Alpine Meadows. When Reily invited them to join him on an excursion into Twin Peaks, White wrote the following story in the December 1963 issue of *The Examiner*:

> *After a long traverse around the needle of Ward Peak to a cornice on the south side of Alpine's ski area, a majestic view of Lake Tahoe spread before us. Reily pointed out where a 50-passenger tram would be in operation next winter. It will rise from a flat area at an elevation of approximately 6,600 feet to the 8,700-foot cornice.*

*We dropped down the North Slope into the first bowl, traversing gradually until we reached the second. Still rimming the area, we discovered another rounded open west slope. Arriving finally on the top of a hill, which seemed to part the valley, we could see challenging runs similar to KT-22 at Squaw Valley. Reily said this would be for future development.*

*Down we skied through crusted snow. Slate ice was only a few inches below the soft powder. Our guide, Eric Johnson, picked a trail between huge ponderosas and firs, across logs, through streams and meadows. We finally came out of the woods on Highway 89 near Sunnyside, just a few miles from Tahoe City.*

With the opening of the Sherwood Forest lift in 1965, skiers no longer needed a weasel to return to Alpine. Early snow signaled the start of a good year, and Reily took full advantage of skier enthusiasm, adding six new members to Twin Peaks' board of directors, including TV personality, good friend and ski enthusiast Art Linkletter. He also enticed investors with the promise of lift privileges and first dibs on a lot in the new development.

In January of that year, the Placer County Planning Commission approved a tentative map for "The Twin Peaks Ski and Golf Club," showing 224 residential lots on one hundred acres. Also in the plan was a chairlift up to Grouse Rock and a nine-hole golf course with a ski lift up the middle that would serve double duty for a beginners slope in winter.

In November 1969, a master plan for Ward Creek Valley, prepared in Sacramento for county planners and paid for by Alpine Meadows, Southern Pacific Land Company, Ward Creek Valley Taxpayers Association and American Development Corporation, was presented to Placer County Planning department for a hearing in Auburn. The proposed plan unveiled a $15 million ski area with a parking lot for two thousand cars, ten new lifts serving five thousand skiers and four thousand home sites in clusters at the end of cul-de-sacs off the main road, as well as two shopping centers and two schools. A "four-lane parkway" running parallel to Highway 89 with an interchange just past Sunnyside at Alpine Peaks Drive was sure to raise some local eyebrows if not the thought of increasing the population from around three thousand to twelve thousand or more over the next twenty years.

County planners, local residents, future homeowners, developers, officials, politicians, environmental groups and the community at large gathered in offices, homes, bars and cafes to discuss Reily's proposed mountain resort. Meanwhile, Ward Creek Valley, with its trout-filled streams rushing down to Lake Tahoe, silently awaited its fate beneath the lofty sentinels of Stanford and Grouse Rocks and Ward and Twin Peaks.

## Chapter 6

# SLIPPERY SLOPES AND
# DIFFERENT FOLKS

## SQUAW SLIDING

By the end of the 1960s, Squaw Valley's "genteel, shabby-snobbish charm," as described by *Sport's Illustrated*, was becoming less charming and increasingly shabby. Cushing's coterie of ski friends from the East Coast, Los Angeles and San Francisco returned to their familiar haunts at Sugar Bowl and Sun Valley—or they ventured next door to Alpine Meadows. Justine Cushing returned to the East Coast, where their three daughters were in boarding school or college. There she could surround herself with her lifelong friends in New York and Newport as the couple headed for a divorce in 1966. Finding little joy in Squaw Valley, Cushing came west mainly to deal with legal disputes, lawsuits or to attend onerous meetings with federal, state and county officials.

In his absence, Cushing's loyal triumvirate of Buchman, Boardman and Burkhart ran the lodge and the ski area. While thousands of eager skiers filled the parking lot on weekends, lined up to buy lift tickets, rode up the mountain on twenty-six different lifts, drank beer in Bar One, ate pizza at the Chamois, carried their trays from the cafeteria to the deck and looked up the Mountain Run to Squaw Peak, Alex Cushing was nowhere to be seen. Most of the area's employees and guests had never met Cushing and never would, and that was how he liked it, having told *Time Magazine*, "I'm terrible with the public. People at resorts like to say the owner talked to them. Here they say, 'That sonofabitch Cushing didn't speak to me for the 13th consecutive day.'"

Cushing was not shy or apologetic about his disdain for the public, but it was his curious disregard for their safety that would plunge the area into disrepute in the early 1970s. Having grown up skiing in an era of family-owned, backyard ski areas, where you would never think of suing the nice family who provided food, lodging and a hill to ski on, and where daredevil skiers accepted (even thrived on) the risk of falling off a lift or down a hill, the idea that he—the owner—was somehow responsible for the safety of thousands of skiers now playing in his backyard perhaps seemed unreasonable.

Most skiers, when they unload at the top of KT-22, follow a "cat track" across a saddle to the top of the popular saddle run—a narrow crossing that can be treacherous when icy and un-groomed (most often the case). Many proficient skiers have paused, looked over the edge, gripped their poles and clenched their teeth as they schussed across the frozen track to safety.

In 1967, an expert skier from Fallon, Nevada, slid over the edge and died when he hit a tree. When Dianna Leonard, also an expert, was killed in the same manner in the same place on February 2, 1971, the ski patrol considered closing the saddle. Cushing, who once questioned the need for a ski patrol in claiming, "Skiers have to take care of themselves," now asserted in *Sports Illustrated*, "There are plenty of people who can handle the saddle under any conditions, and the skier has to be his own judge. We've got some of the best skiers in the world here and we're not going to try to tell them what to do."

In his annual letter to season pass holders, he wrote, "The skier who was killed on the mountain went out of control and hit a tree. What can you do about it? A sad occurrence, but skiing is inherently risky."

The traverse was eventually widened, and a road was built around the back to access Olympic Lady on the east facing side of KT.

As manager of Cushing's "uphill transportation business" for the previous year and a half, Hans Burkhart kept a log of all the lifts, noting when they were installed, scheduled repairs and what parts to replace. He prioritized repairs, prepared a budget and reported to his boss, whose adversity to investing in repair and maintenance was a constant source of frustration for Burkhart. "Alex would rather spend money on paint than fix his lifts," Burkhart says with a chuckle. "One year, his sister, who was a decorator, wanted us to paint the chairs pink, blue and mauve." Redecorating the lodge, purchasing new furniture or building a first-of-its-kind never-seen-before ski lift appealed to Cushing more than maintaining the lifts he already had.

When Burkhart asked Cushing to buy walkie-talkie radios for the lift crew, Burkhart remembers:

Looking up the west face on the north slope of KT. *Photograph by Hank de Vre.*

*Alex said I was crazy, and when I told Cushing he needed a base station and a shop for maintenance, he said, "Why do we need maintenance? I just bought those lifts?" Alex always bought the cheapest machinery, and he would never pay to maintain it.*

One week after the second ski fatality on KT, on a cold, blustery Wednesday, ten skiers riding up the Emigrant lift suddenly dropped ten feet onto the cold, hard snow. Eight were injured, three with serious head and back injuries. Had the accident occurred on a sunny weekend, there could have been one hundred skiers on the lift instead of ten.

When Burkhart arrived at the top terminal to inspect, he found that the 3,200-foot cable, which supported the chairs, had derailed from the bull wheel and wrapped around the shaft. On discovering that four sheared bolts had dislodged the bull wheel, he told Cushing they must close the lift, remove the cable and either repair or replace it.

Cushing deferred to his son-in-law, Yanik Kunczynski, whose company (Lift Engineering) had installed the lift in 1964 (one of the first of his four lifts). Kunczynski's solution was to put everything back together and let it run, and Cushing did just that.

Burkhart was livid, and he expressed years of pent-up frustration with Cushing's lack of interest in caring for his equipment to Bob Lochner at the *San Francisco Examiner*, protesting, "Everyone knows the lifts are a piece of junk. They're falling apart, and there's no money for improvements." Claiming he could no longer be responsible for the safety of the lifts, Burkhart quit, bringing even more negative media attention to the "un-safe conditions" at Squaw Valley.

Cushing responded by saying that he was going to fire Burkhart anyway and filed a suit for "conversion of funds," claiming that Burkhart had expropriated for personal use some of the funds designated for lift improvements. Burkhart countersued for $7,700 in unpaid wages and then filed a $2 million libel suit for allegations Cushing later made on a radio interview. They would meet in court a year later.

With two ski fatalities on KT, a serious lift accident on Emigrant and two Superior Court charges filed against Squaw Valley for operating the Gold Coast lift without emergency brakes, Cushing called a press conference in San Francisco to deny charges of negligence and to restore Squaw's slumping sales and reputation.

Having replaced Burkhart with Dick Reuter, an experienced mountain manager and former employee, Cushing spoke in his own defense. Regarding

the deaths on KT-22, Cushing said he spent money to eliminate the hazard but that the U.S. Forest Service refused to issue him a permit to remove the trees that caused the two deaths. (He did it anyway—without the permit.) As to the Emigrant chair derailment, Cushing produced a letter from the State Industrial Safety Code stating that the lift had been inspected in January and that the "four sheared bolts were concealed and impossible to detect until the structure failed." Squaw Valley was cleared of negligence. Cushing said the lift manufacturer (his son-in-law, Kunczynski) would be held responsible for costs and damages. On the charges by Burkhart, Cushing stated that $636,000 had been spent on lift maintenance during Burkhart's employment and that "he had complete control and plenty of money." Burkhart maintained the figure was closer to $60,000.

Few people outside of Squaw Valley knew that later that spring, the Exhibition Lift in front of the lodge, where the Squaw Valley junior ski team trained, suddenly started rolling backwards. Those who were quick to react and were not too high off the snow jumped. An attentive lift operator at the bottom grabbed passengers off the lift as they arrived at the platform, flinging them right and left in a heap of bodies, skis and poles.

No one but Burkhart and Cushing knew why, one sunny, windless day in 1968, the gondola was closed. Wondering why the gondola kept hanging up on the lift, Burkhart stopped on his regular morning survey to climb down the ladder into the pit beneath the gondola and check the eighteen-ton counterweight. When he placed his ski boot on it and gave it a firm shove, it fell off, resulting in a thunderous bang that rocked the building. "The cable flew up. Cars shot forward. I thought it was an earthquake," Burkhart recalls. Shaken by the thought of what might have occurred had they opened the gondola for the public, Burkhart told Cushing, "No gondola today!"

When the two adversaries finally met in court a year later, Burkhart, now living with his family in Snowbird, Utah, won his case and settled for $18,000. Afterwards, Cushing congratulated Burkhart and invited him to lunch, where Cushing immediately asked Burkhart's advice on all the questions he had been saving up during Burkhart's absence.

# Alpine Rising

In a March 1967 report to Alpine Meadows stockholders, Byron Nishkian wrote, "Time lost due to mechanical failure of the lift facilities is at the lowest point in the history of the company," and he credited "improvement of lift

Alpine Meadows brochure marketing "the good old-fashioned hospitable ways of doing business that never go out of style." *Courtesy of Alpine Meadows.*

and hill maintenance" as key components in a 30 percent increase in revenue from the same date the previous year. Unlike their neighbors, Alpine bought better equipment, built a big garage for grooming machines and employed experienced personnel for summer maintenance.

By the end of its first decade, Alpine's reputation as a family-friendly destination was firmly established. Although the concept of marketing didn't exist in western ski areas in the 1960s, Alpine somehow got it right. Whether it was the old-fashioned lady in a red dress on long-board skis (super-imposed on Alpine Bowl), the annual "Art Linkletter Family Slalom" or the establishment of a Children's Day School, Alpine's attention to the needs of the skiing family attracted many more skiers than original forecasts projected and guaranteed generations of Alpine fans.

The February issue of *Pictorial California* praised Alpine Meadows' "widespread reputation for its highly successful job of catering to the skiing family looking for wholesome

Family at Alpine. *Photograph by Donald E. Wolter.*

recreation, congenial hospitality and the finest ski facilities for every member of the family." No doubt with neighboring Squaw Valley in mind, the article continues, "It is admirable, if not unique, that Alpine has devoted its services to the family market when many areas in California and throughout the country are appealing to 'swinging singles' and a mass, here-today gone-tomorrow, one shot clientele."

Whereas Squaw Valley après-ski social life took place in the lodge bar (Cushings, Bay Area skiers, management and select ski instructors) or the Bear Pen (local residents and employees), Alpine skiers gathered with their families and friends in front of stone fireplaces in newly constructed mountain cabins hidden amongst the pines along Bear Creek and in Alpine Estates.

The old Deer Park Lodge on the Truckee River at the entrance to Alpine, now owned by San Francisco bon vivants Gardiner and Lani Mein and renamed the River Ranch, became the watering hole of choice for dinner and a lively bar scene and was frequented by homeowners and visitors from both areas.

Aprés-ski in the McKleroy home. *Photograph by Donald E. Wolter.*

Aprés-ski with the Kimball family. *Photograph by Donald E. Wolter.*

When Alpine gave members of the Lake Tahoe Ski Club season pass discounts, a locker room and place for their junior alpine team to train, they made a long-term investment in local good will.

One of the oldest ski clubs in the country, the Lake Tahoe Ski Club was founded in 1929 when the Tahoe Tavern (a luxurious resort on the lake where the train from Truckee terminated) announced it would not open for winter and therefore would be unable to sponsor the national jumping and cross-country races scheduled to be held in 1932 in Tahoe City. Rising to the occasion, the club elected officers and raised $10,000 to build a jump hill worthy of the first national ski meet held west of the Rockies.

Since that day, just about everyone who lives in North Lake Tahoe has been associated with the Lake Tahoe Ski Club. In their early years, the club cleared cross-country trails, maintained a sixty-meter jump on Olympic Hill, sponsored meets, invested in equipment, provided instruction for members and gave lavish parties with music, dancing and beauty contests. At the 1939 National Ski Association Meet, in which young Poulsen competed, events included jumping, cross-country, slalom and "down mountain." One competitor commented that the real race was to get to each event on time.

More recently, the club had sponsored Nordic and Alpine events in Squaw Valley in the 1950s and was a sponsoring club for the 1960 Olympics. With a large active membership in the North Tahoe community, the club was pleased to find a permanent home at Alpine Meadows. By this association, Nishkian, an FIS officer and enthusiastic supporter of international ski racing, gained local support and sponsorship for national and international alpine events to be held at Alpine, beginning with the U.S. Junior Nationals in 1964 and the return of the Far West Kandahar in 1965 and 1967.

Sanctioned by the Ski Club of Great Britain in 1938, the Far West Kandahar had alternated between Yosemite National Park, California, and Mount Hood, Oregon, until 1942, when it was abandoned due to war time restrictions until 1962, when the race returned to Oregon. At the 1967 event in Alpine, competitors from Canada, the United States, five Alpine nations, England, Japan, Australia and Chile stayed in homes in Alpine Meadows. Working together on this international event, the ski area, the community and the Lake Tahoe Ski Club strengthened their bonds.

Although a few stockholders objected to the ski club setting a downhill course across their favorite run and closing a slope for afternoon training, the ski area had every reason to be proud of the Lake Tahoe Ski Club's

Kandahar course on the "Promised Land." *Photograph by Donald E. Wolter.*

Winners Nancy Greene, Heidi Zimmerman and Gertrude Gable Kandahar. *Photograph by Donald E. Wolter.*

junior race program, which produced many U.S. Ski Team members and future Olympians, including Greg and Vickie Jones, Cheryl Bechdolt, Bobby Ormsby and Lance, Eric and Sandra Poulsen. Coached by Argentine Olympian Osvaldo Ancinas, Pepi Greimeister and Bud Jones (father of Greg and Vickie), team members consistently placed in the top ten at regional and national races. Competitors, coaches, parents and local citizens were proud of their team and would call Alpine their home area wherever their skis took them.

## Alpine Slipping

While Squaw struggled to regain its reputation after allegations of negligence resulting in lift accidents in the late 1960s and early 1970s, Alpine struggled for its financial life. Both areas were competing for skiers during a heady expansion of improved facilities around Lake Tahoe. Luggi Foeger left Alpine to manage Incline Village (renamed Diamond Peak), where he laid out new trails and installed the first snowmaking equipment in the Sierra. Heavenly Valley, Kirkwood and Northstar added lifts, opening more terrain. Improved highways from the Bay Area and Reno brought more people to the mountains faster. Even with the added lift capacity into Ward Valley, Alpine's loyal skier base didn't increase sufficiently to pay for all the improvements.

When things at Alpine began to look really grim, the board hired Alan Ewen, hoping his corporate experience would make AMOT, Inc. attractive to a potential buyer. He set up his office on the top floor of the lodge overlooking the parking lot—a space fitting the president and CEO. He then gathered the key employees, explained their duties and gave them appropriate titles. Howard Carnell, who oversaw base area equipment, roads, parking lot and ski lifts, was named plant superintendent. Werner Schuster replaced Foeger as ski school director and, as the best spokesperson for the area, also became public relations/marketing director.

In spite of Ewen's corporate overhaul, the area continued to lose money. At a 1969 meeting of the board of directors, they discussed filing for bankruptcy. Realizing they couldn't afford a high-salaried CEO, Ray Johnson, a member of the board who had a financial interest in the company, volunteered to take over the management. He applied a severe austerity program, letting go almost all employees except for management

and a few key players. In order to get the remaining employees off the payroll in summer, Larry Metcalf found jobs for them at his Rubicon Bay estate, where Carnell and Schuster spent their summer clearing manzanita brush.

## ALPINE RESCUED

Nick Badami loved the business of skiing, and Alpine was the perfect place for him to work his magic. When he took over a controlling interest in Alpine Meadows in 1971, he didn't fire and rehire employees. He sought out their advice. Just as he trusted his mountain managers to do their job, he left the ski shop and food service to local concessionaires, allowing them to prosper along with the ski area.

A graduate of the Wharton School of Finance at the University of Pennsylvania, Badami's good business practices and innate acumen was just what Alpine needed. "When I took over Alpine Meadows, the resort had good people and a wonderful reputation with its customers," Badami told Bob Frohlich in an interview for his book *Mountain Dreamers*. "The problem wasn't in the resort's operation. It was lacking in basic business principles. I had to become a teacher in business planning and control. It's as simple as that," Badami added.

Born in New Jersey, Badami was not an avid skier looking to live in a ski area. He didn't need to prove himself, having taken BVD apparel from the verge of bankruptcy in 1940 to a position of leadership in retailing and manufacturing by the time he retired at age forty-nine. Badami knew that skiing's greatest asset was fun and that Alpine's competition was as much a resort in Hawaii or Mexico as it was another ski area. To ensure the fun factor, he concentrated on the skier experience—courteous and capable lift operators, good relations with the community, improved food and a dining room with table service and above all, the best on-snow experience a lift ticket could buy. With ample snowmaking and good grooming, local skiers quickly learned that Alpine might not be the biggest area, but it did have the best snow conditions.

Badami loved the ski business for its bright young minds and the passion they had for their sport, and he gained their respect with his wise leadership and personal warmth. While on a trip with his son Craig to Park City, Utah, in 1975, Badami learned that the ski area was for

sale. He saw the same potential to apply a good business approach to a fun industry. After he bought the ski area with its ancillary businesses, he immediately got rid of them, explaining in an interview with Mark Manlove for *Park City* magazine:

> *The reason was twofold: first, to allow the company to do one thing well. "When we got involved, the company was running the construction, real estate, restaurants, retail, interior design, everything," Badami said. And second, to provide opportunity to small private enterprises. "Instead of competing with these young people who were coming here, we wanted to encourage them," he added.*

Dividing his time and talent between the two areas, Badami's fondest dream would have been to see his only son grow up in the business he loved and to share in his success. That dream ended tragically, however, when Craig, at age thirty-seven, was killed in a helicopter accident in Park City in 1989.

In spite of his family's great loss, Badami continued to make a difference to the ski industry on many levels. Having launched (with Craig's enthusiastic participation) the U.S. World Cup Opening in Park City in 1986, Badami went on to serve as president of the National Ski Areas Association and chairman of the U.S. Ski and Snowboard Association, as well as a board member of the Salt Lake City 2002 Olympic Organizing Committee.

# TWIN PEAKS ESTATES

John Reily focused his considerable energy and dwindling financial resources on developing his real estate venture in Twin Peaks throughout the 1970s. In 1975, he signed a quitclaim with Southern Pacific Land, releasing his title to the fifty-five-year lease he had signed in 1958 on the land from Alpine Meadows Road up and over KT-22 in Squaw Valley. When Nick Badami introduced him to Don Pritzker (Hyatt Hotels), Reily took advantage of the opportunity to sell his home overlooking Alpine Meadows, as well as his interest in Alpine Meadows of Tahoe, Inc., thus ending Reily's financial ties to the area he founded—but not his emotional ties.

Winnie had returned to city life, the beginning of a permanent separation. Reily moved into his new cabin in Twin Peaks Estates and continued to

promote the joys of homeownership at or near the base of Alpine's Sherwood Forest lift, where Alpine now sold lift tickets to skiers arriving by shuttle bus from Tahoe City and Sunnyside.

In a letter to the Tahoe Regional Planning Agency (TRPA), Reily's nephew, John Lloyd, described the advantages of homeownership in Twin Peaks as not having to drive to a ski area, not having to look for a parking space in a huge lot, not having to repeat the process for forgotten goggles or mittens and not having to eat lunch or wait for family and guests in a crowded cafeteria. Neighboring Sugar Bowl had enjoyed this skiing lifestyle for forty years, and a ski-in/ski-out mountain village on the slopes of Snowmass, Colorado, was well developed by the late 1960s. Deer Valley in Utah would soon follow. Meanwhile, back in Ward Valley, plans for a two-building complex with one hundred condominiums on twenty acres adjacent to the Sherwood Forest lift were on the drawing boards at Enteliki, the architectural firm that designed Snowbird in Utah.

Reily's belief that he could establish a similar experience in Ward Valley never wavered, as he appeared at planning meetings from Tahoe City to Auburn with his white hair growing whiter, beard and mustache trimmed and blues eyes sparkling in anticipation of his next great idea.

# POST-OLYMPIC BLUES

After the 1960 Olympics, the state entered into a lease agreement with two concessionaires. Squaw Valley Development Corporation (Cushing) leased two ski-lifts (Red Dog and Siberia) on 1,000 acres of state land and operated the ski area, the Squaw Valley Lodge, restaurant, bar and hotel rooms. Squaw Valley Improvement Corporation (William Newsom Sr., a friend of then-governor Pat Brown) leased the Blyth Arena, Papoose Ski Area, the Hofbrau restaurant in the California Building, a movie theater in the Nevada Center, the Olympic Village and the "Hub"—a large reception and dining area with a bar, kitchen and assorted press buildings and parking lot.

Throughout the 1960s, Cushing struggled with accusations and mandates from the U.S. Forest Service and state and county officials and complaints from disgruntled skiers about the cleanliness of the lodge, the mediocre food, lack of guest services, surly employees and the safety of the lifts. Nevertheless, locals and visitors enjoyed skating programs and hockey games

Skaters in Blyth Arena. *Photograph by Tom Lippert.*

in Blyth Arena, and busloads of students (and many parents) came from Bay Area schools on weekends to learn to ski at Squaw.

The Olympic Village, with its four three-story buildings—each with eighty six- to eight-person dormitories and separate bathrooms for men and women on each floor—was the ideal affordable lodging solution for busloads of teenagers in Bay Area learn-to-ski programs. They arrived on Friday night, attended a teen dance in the Hub, skied all weekend, ate in the cafeteria and left Sunday afternoon. Annual school trips from Southern California had longer stays. Bill Parson managed the whole operation, and when his wife, Norma, joined him in 1965, she named their one-thousand-kids-per-weekend operation the "Super Zoo." In the summer, they ran sports camps, including pom-pom, cheerleading, basketball, gymnastics, wrestling, football and hockey camps.

When the parking lots and surrounding structures weren't filled with the shouts of cheerleaders and the grunts of wrestlers, the Hub became a conference center for everything from Lawrence Radiation Labs with Nobel Prize Winners to Catholic nuns in full habit to the Student International Meditation Society (SIMS) led by Maharishi Mahesh Yogi. When that event mushroomed from three hundred anticipated guests to one thousand, the ever-resourceful Parsons found beds in the Squaw Valley Lodge and in homes throughout the valley.

In spite of these popular programs run by the state's lessees, by 1966, annual revenue from leases was reported to be $128,000, with operating expenses of $418,000. This was partly due to an agreement the state had with the federal government to pay for maintenance and upkeep of the Olympic facilities (e.g. Blyth Arena, the Olympic Village and their surrounding parking lots). After investing over $9 million to build the Olympic facilities in Squaw Valley and losing about $300,000 a year, state legislators agreed that even the increase in tax revenue generated by the resounding success of the Olympics was not enough to justify their continued support of the Olympic facilities in Squaw Valley.

After the Department of Parks and Recreation recommended the state divest itself of this "white elephant," the state legislature passed a bill in 1967 to sell the state's assets, including the leases. A financial analyst for the legislature commented, "This is a state-subsidized private operation"—the private operation, of course, belonged to Alexander Cushing.

In Cushing's July 1972 newsletter, he announced the opening of the Squaw Valley Tennis Club, which boasted six courts and a clubhouse (converted Gingerbread House) in front of the lodge operated by Paul Rivard. Squaw's residents transferred their enthusiasm from the slopes to the courts as they enjoyed clinics, tournaments, tips from visiting pros and after-tennis cocktails at Buchman's house next door. Cushing loved tennis—perhaps even more than skiing. Buchman, who never skied and proudly claimed that baseball was a far superior sport to skiing, also loved tennis.

Oakley Hall and Blair Fuller, writers, skiers and tennis players, conceived the idea for a summer writer's conference in 1969 and held the first conference the following summer. With mutual friends in the world of art, literature and tennis, Cushing often joined the Halls, Fullers and staff on the court. He was a great supporter of the Squaw Valley Community of Writers and proud of its national reputation. Students like Michael Chabon, Amy Tan, Richard Ford and many others developed their stories, found agents, published books and eventually joined a prestigious staff that included Peter Mathiessen, Mark Childress, Diane Johnson, Anne Lamott, Jim Houston, Robert Stone, Alan Cheuse and a growing list of writers, poets and screenwriters who continue to share their wisdom and advice with students every summer in Squaw Valley.

## SQUAW FOR SALE?

In January 1971, the state announced they would accept bids for their Squaw Valley holdings. They received one bid for $25,000, submitted by John Fell Stevenson on behalf of Ski Properties, Inc., whose investors included William Newsom Sr. and Ben Swig, a well-known hotel and commercial real estate owner/developer and mastermind of the Fairmont Hotels. Stevenson invited his friend and ski area expert Bill Janss (Snowmass, Sun Valley) to come have a look at the lifts. With Janss's approval and Swig's expertise in finance and hotel management, Stevenson was confident in the company's success. Newsom was not. The offer was not accepted.

The next customer was Dick Baker. In February 1973, his Australian company, Mainline Corporation, Ltd., made an offer to purchase the state's assets for $25 million plus 1,500 acres of land from the Poulsens. With that news, skiers, taxpayers, business owners and government officials heaved a sigh of relief from the Sierra to Sacramento. Having lost about $11 million since 1960, the state would no longer have to "subsidize" Cushing's ski area.

Cushing and Dick Baker. *Courtesy of Squaw Valley Ski Corp.*

Baker, having observed the real estate potential in nearby ski areas Northstar and Kirkwood, entered into a partnership with Poulsen to develop 1,400 units in town houses and fifteen-story condominium buildings on 1,290 acres of land owned by Poulsen. Poulsen and Cushing—the two most powerful men in the valley—could never have had a business partnership given their acrimonious relationship over the past twenty years. Now, thanks to Baker, both men could prosper without having to speak to one another.

A land exchange between Mainline and Cushing's Squaw Valley Development Co. (now called Squaw Valley Ski Corp.), resulted in Ski Corp. owning 2,500 acres of skiable mountain real estate as well as the two lifts previously owned by the state. Part of the exchange was the Squaw Valley Lodge, an enterprise Cushing was never keen on (much less running the restaurant). With all its facilities, including twenty-four lifts, the tram and the gondola and a restaurant and bar at Gold Coast under one owner (Cushing) on private land, Squaw Valley entered a new era debt-free and financially positioned to expand and improve its mountain facilities.

Baker's first priority would be a $1.5 million overhaul of the lodge and the Olympic Village beginning that summer. With sole ownership of everything in the valley, Baker and his associates announced plans to invest $200 million over the next twelve years in a "European Pedestrian Village" that would include housing, shops, restaurants, sports facilities including golf and tennis and an educational institute and theater that would "support year-round scientific studies and writer's forums."

With his rugged good looks, soft Australian accent and big ideas, Baker and his California beauty queen wife, Joan, were embraced by a community that admired risk-takers and loved visionaries who believed (and invested) in their ski area. The Bakers and their sons settled in a house on the Truckee River at the entrance to Squaw Valley and became active participants in all the recreational and social activities their new home had to offer.

Homeowners looked on with fascination at plans by famed architect I.M. Pei for a "Serpentine Village" that meandered down the valley, but before they had time to endorse, complain or even comprehend the plan, news of Mainline's financial collapse in Australia hit the news. In August 1974, with $1.5 still owed to the state, the company placed itself in receivership to an Australian-New Zealand banking group. With $105 million of assets in Australia and $50 million in the United States, Baker agreed to put the company's U.S. assets on the market first in order to pay their creditors.

Once again, Squaw Valley was for sale—but not all of it! Cushing assured season pass holders in his September 1974 letter that "Ski Corp. will not be

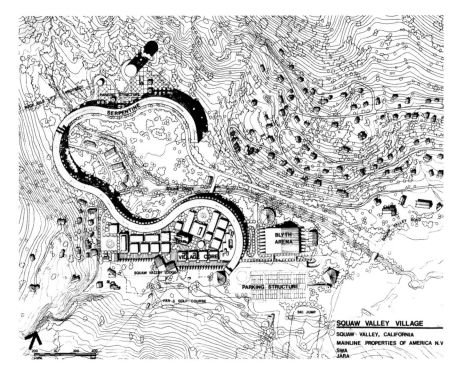

I.M. Pei's Serpentine Village. *Courtesy of the Poulsen family.*

adversely affected, as it has no financial ties with Mainline." Baker backed him up in a statement to the *New York Times* in which he said, "No ski terrain or ski facilities are included in the Mainline properties. They belong to the Squaw Valley Ski Corporation…to Alex."

With Mainline in a holding pattern, the Parsons left the Olympic Village in 1974 to manage the Squaw Valley Lodge. Bob Dal Bon, owner of the local market, took over as caretaker of the now abandoned village.

## The Next Great Idea—A U.S. Olympic Training Center?

Mainline and its creditor banks found a potential buyer one year later when the United State Olympic Committee (USOC) considered Squaw Valley for a year-round training center. Plans included construction of an Olympic-sized swimming pool, a speed-skating oval and track and field facilities. By

enclosing Blyth Arena, they could use it for gymnastics, fencing, weight lifting, boxing and judo, as well as hockey and figure skating.

Athletes would revolve in and out throughout the seasons, with Alpine and Nordic training in winter, cycling and kayak sports in summer and the rest all year-round. Skaters and hockey players could stay and attend local schools.

The four hundred to five hundred homeowners in the valley saw it as an opportunity to put the Olympic facilities to good use and bring new life to the area after the disappointment of Mainline. Joe Marillac commented, "It would be much better than having ten thousand people overrun us for a rock concert," a reaction to a recent suggestion to bring people to the valley. Another resident lamented the loss of low-cost rooms in the Olympic Village. Bill Boardman of Ski Corp. said the training center would not affect the thousands of skiers who came to Squaw on weekends, and some of their sports—figure skating, ice hockey, ski jumping and ski races—would provide diversions for skiers.

In December 1976, the banks that held the mortgage on the Olympic Village signed a lease with the USOC for $12,500 a month for twelve years with an option to purchase. The U.S. Forest Service leased them the Blyth Arena for $22,500 a year, and in June 1977, athletes began to arrive at the almost-ready facilities.

Lew Whiting, a retired army colonel, came in April to direct the operation and get the village up and running for the first group of athletes, ninety-three soccer players arriving in May. With athletes traveling to local gyms and lakes (Tahoe and Donner), training in Quonset huts set up in parking lots and running up and down the roads of the valley, Squaw looked forward to a renewed Olympic spirit.

*Chapter 7*

# Three Tragedies, Two Fantasies and a Work in Progress

## The Tram

By the spring of 1978, Squaw Valley ski lift accidents had disappeared from newspaper headlines and from the memory of its thousands of skiers who rode the lifts with carefree anticipation of the next run. Then, on a cold, blustery day in April, one of the worst disasters in ski area history occurred late in the afternoon as gale-force winds whipped the snow into a full-force blizzard.

As the storm intensified, forty-four skiers and tourists, including birthday celebrants who were not dressed for skiing, boarded the red cable car in the tram building at High Camp to take the five-minute ride to the bottom. Meanwhile, sixty-four skiers climbed aboard the green car at the base to ride up the mountain for their last run of the day.

The upper car left at 3:30, advancing slowly in the wind for about two hundred feet. Then, suddenly, a strong gust struck the nine-ton cable car, spinning it sideways and derailing one of the support cables. When the cable broke free, the car with its terrified passengers plunged seventy-five feet and then shot upward and collided with the loose cable that came crashing down through the roof like a giant axe, pinning twelve people on the floor. Three died instantly. Others, suffering from cold, shock and injuries including fractures, concussions and contusions, lay on the floor of the cabin. One passenger fell through the sheared door, landing on rocks and snow eighty feet below. He managed to make his way through the

blizzard down remote Shirley Canyon to safety. No one knew about him until the next day when he visited the doctor's office and was diagnosed with a broken rib.

When ski patrol leader Jimmy Mott heard on his radio that something had happened to the red tramcar, he rushed to the base station to ride up on a special rescue car, only to learn that it was impossible without a functioning cable. Using another lift and skiing to the scene, he found ski patrolman Chris Phillips waiting for the tram operator to drop a rope and hoist them both up to the stricken car. Mott called for help as he and Phillips tried unsuccessfully to pry the cable off the victims. They administered first aid as best they could, all the while talking and trying to calm the passengers, assuring them that help was on the way and that the car was stable and would not fall to the rocks below. Soon, John Krause, lift maintenance supervisor, joined them, having climbed the nearest lift tower and crawled along the two remaining cables to the dangling car.

Meanwhile, the green ascending cable car stopped abruptly just below a steep rocky cliff. Firmly shaken and cold but not injured, the sixty-four passengers had no idea why they were left hanging over the highest spot on their journey from the base to the terminal at High Camp. When at last the ski patrol radioed the tram operator that an accident had occurred and that the tram would not be running, the passengers learned they would have to be lowered by rope through the trap door—a process that took eight hours.

When Dr. Charles Kellermayer heard the conversations on the monitors in his medical clinic in Squaw Valley, he grabbed his skis and fifty-pound rescue pack and hurried to the scene of the accident. His first priority was to save a woman with serious injuries, pinned under the cable. That effort ended tragically, as she became the fourth fatality.

In spite of the cold, howling wind and near darkness, Kellermayer found the passengers remarkably calm and cooperative, and he credits Mott and Phillips' cool professionalism in averting panic or hysteria. After determining the extent of the injuries, Kellermayer, Mott and Phillips decided on an order of evacuation—the most severely injured first, then children, then parents.

While the blizzard roared on, snow accumulated and darkness fell, rescue operations were in full operation. Jim King, one of the first to look up at the cable car dangling above an isolated incline, had quickly determined that no over-the-snow vehicle could reach this spot. While the men in the car planned how they would get them out, King began to organize the rescue operation on the ground—an agonizing process that

wouldn't end until Mott brought the last passenger out ten hours later at 1:15 a.m.

As word got out, one of the greatest rescue stories in ski history began to unfold. Soon, every member of the medical community had arrived in Squaw—some up on the mountain, where they set up emergency clinics at High Camp and in the gondola building at Gold Coast, and others at the base in the lodge and at the adjacent medical clinic. Search and rescue volunteers made their way up the canyon, searching for fallen passengers. Arriving at the site, they found a bonfire, where Ernst Hager (U.S. Ski Team coach and later mountain manager) and others were waiting to help the wounded passengers down onto the snow. With winds gusting at sixty miles per hour, volunteers and ski instructors, led by director Hans Standteiner, helped and, in some cases, carried victims up the steep, slippery trail to safety in the tram building. From there, snow cats were ready to ferry them to the gondola and a ride back down to the lodge.

One gentleman, the limo driver for the birthday group, was wearing black patent leather shoes. A patrolman crawled up the trail with him, holding his foot from sliding at each careful step. When they arrived at the tram building, he thanked the patrolman and passed out.

Tram accident. *Courtesy of Squaw Valley Ski Corp.*

Meanwhile, down in the valley, blankets were stripped from beds in the lodge and sent up the mountain. The Lucky store brought boots from Tahoe City. Food was brought in or supplied by the lodge food service, and local residents lined up to take families, friends and relatives into their homes. Ski patrol members from Alpine Meadows, Boreal Ridge, Northstar and Heavenly Valley joined volunteer firemen from all of North Lake Tahoe, California State Highway Patrol and even the Reno Civil Air Patrol.

When Hans Burkhart was asked years later why he thought this accident occurred, he said it was probably the wind and that no one could have predicted it and no one will ever know why it happened.

Aided by heroic and professional employees and hundreds of dedicated volunteers, after thirty winters of triumphs and disasters, this was Squaw Valley's finest hour.

# A SKI CIRCUS

In January 1979, the U.S. Forest Service announced its intention to address the increasing demand for expansion and development of ski areas on federal lands in California. State senator Alan Cranston applauded their intention, informing them that the demand for skiing in the state had increased at a rate of 8.5 percent since 1974.

Doug Pfeiffer, editor in chief of *Ski* magazine, pointed out in a letter to the Tahoe Regional Planning Association in 1979 that "skiers migrate to the mountains, take jobs, build homes and impact the roads, the water and the general environment." These facts informed the Committee for Establishing Criteria for Development of Ski Areas (CTRPA), whose members were ski area operators, planners and technicians and whose mission was to develop a general plan for ski area development in North Lake Tahoe, which they would present to Placer County as a solution to increasing traffic and environmental concerns.

Squaw Valley architects David Tucker and Tim Ward took on the task of designing a "Ski Circus" that would interconnect ski resorts between Interstate 80 and Lake Tahoe. Skiers could travel from Boreal Ridge on Donner Summit to Homewood on Lake Tahoe through a combination of lifts and ski runs at Boreal, Sugar Bowl, Squaw, Alpine and Homewood ski areas. Buses, ferry boats, bike paths, pedestrian walkways and park-and-ride lots would all be part of a transportation system to reduce automobile traffic.

Tucker and Ward conceived this plan in 1971 after a trip to the French Alps, where they used a vast network of lifts to ski from one mountain village to another. In proposing a similar project in the Sierra, Tucker wrote:

> *Rather than construct unrelated areas distant from one another and from existing roadways or transportation systems, this plan proposes that the demand for new ski areas be met by constructing resorts along the Sierra crest linked to one another and to existing areas by their ski lifts and by a parallel regional transit system running through the Truckee River Corridor from Truckee to Tahoe City. This concentration of skiing would minimize the impact on the Sierra environment by eliminating separate roads to distant areas. It would provide the opportunity to solve existing traffic problems by creating a reasonable tax base for the capitalization of a regional transit system and attract vacationers from around the world for every season.*

Letters of support for this plan came from state senators, congressmen, local businesses and skiers near and far. Skiers and ski area operators applauded the idea of greater, more varied terrain. This concept was described temptingly by Wes Howell, chairman of the CTRPA, in a letter to the Governing Board of the Tahoe Regional Planning Agency: "Although we have some excellent ski areas, we do not have any large, expansive skiing where a skier can spend the day going from one place to another always finding something new."

Jay Price, president of the National Ski Areas Association, wrote, "The 'Ski Circus' approach would greatly expand the ski terrain but with relatively minimal development of facilities."

Ski visionaries from Poulsen and John Reily to area developers Nick Badami and Alex Cushing have all looked beyond their boundaries to the possibilities of combining them in a "Sierra Ski Circus." The dream lives on.

# How to Buy an Olympic Village

Athletes training at the U.S. Olympic Training Center in Squaw Valley saw their Olympic dreams fade into an uncertain future when President Jimmy Carter announced that the United States would boycott the 1980 Moscow Olympics if the Soviet Union did not withdraw its troops from Afghanistan. By the end of 1979, athletes, coaches and officials had left the Squaw Valley

training center for Colorado Springs, where the U.S. Air Force Base offered their facility to the U.S. Olympic Committee for one dollar.

Since Mainline's demise in 1974, Bank of America, Australia-New Zealand Bank and Schroeder Bank (based in London) were the principal banks holding the property. Every few months, the Schroeder Bank sent a representative from New York to inspect their holdings, conspicuously prowling the premises in a dark overcoat.

Their property included the seventy- and ninety-meter ski jumps, the main parking lot on the south side at the head of the valley (current location of Intrawest Village) and the Olympic Village, with its one hundred surrounding acres at the base of the mountain. Logically, they approached Cushing first to see if he was interested in buying these holdings, but Cushing turned them down. He had an easement, established with the state in the 1960s, for use of the parking for day skiers until a new village was developed as a destination resort with overnight accommodations.

It was to the man in the dark overcoat that Phil Carville directed his call in 1979 to inquire about their intentions for the Olympic Village and to arrange a meeting on his next inspection tour of Squaw Valley. Carville, the former president of Trimont Land Company and developer of Northstar, had just finished a successful condominium development at Northstar and was looking for a new project in a mountain community.

After their meeting and months of complicated negotiations, Carville secured an option to purchase the banks' holdings for $3 million. Carville writes, "I couldn't believe the price. Now I had to find the money. I needed some partners."

Carville went to Eureka Savings and Loan in San Francisco, having already partnered with them in a joint venture in which they had profited substantially. Wary of a contentious relationship between the two brothers who controlled Eureka S&L, Carville looked for another partner to balance it out, but that effort failed when the potential partner learned who the other partner would be. Pleased to have the funding for a project in Squaw Valley, Carville settled for a partnership in which he owned 33 percent and Eureka owned 67 percent, and he hoped for the best with his new partners.

Having been rebuffed by Cushing in the past, the banks did not inform Ski Corp. of their negotiations with Carville. However, before escrow could close, Cushing, Carville and his investors would have to settle the issue of Ski Corp.'s conditional use permit (CUP) on the parking lot. Carville arranged a meeting in San Francisco with some trepidation for the personalities involved.

At that meeting and over the course of many more, Carville describes the clash between Cushing and Kidwell, the president and CEO of Eureka, as a "Boston, lace-curtain Irish versus San Francisco hard-knock Irish." The more Kidwell perceived Cushing as an arrogant and disapproving easterner, the more Kidwell struggled (unsuccessfully) to prove his equality. Weeks of soap-opera-worthy meetings finally culminated in a showdown with five principals, including representatives from the Bank of America and ten lawyers from the title company in San Francisco. After more verbal posturing on both sides, a deal was finally made. Carville and his partners now owned one hundred acres at the base of Squaw Valley. They celebrated their purchase at a nearby restaurant and named their company Olympic Valley Associates. Their plan was to develop a dense pedestrian village similar to mountain resorts in Europe. In 1980, they toured several of those resorts and began to plan their Olympic Village.

When they returned, they learned that the Federal Reserve, in an effort to curb inflation, had raised interest rates to member banks and savings and loan associations as high as 20 percent, effectively killing the housing and resort industry for the years ahead. The institutions also had to borrow at high rates to sustain their loans, resulting in Eureka charging 15 percent interest on money Carville needed to go forward with his project. With such high interest rates and loans hard to come by, Carville had to rethink his plan to build and sell condos. Even if he could get the money, issues regarding sewer capacity in Squaw Valley had resulted in a moratorium on building. No building permits could be issued for new developments.

Faced with these barriers, Carville tried to convince Eureka they should wait out the adverse economy, but Eureka had its own interest rate issues and wanted to press on. With Eureka charging interest rates over 15 percent, no market for condos and Cushing pursuing litigation to prevent them from building in the parking lot, Carville reluctantly turned to time shares, a market he didn't embrace but saw as his only opportunity.

Carville tore down three of the old dormitories and rebuilt and refurbished two others on the original foundations. Although they didn't own the Hub, they were allowed to use it as a common-use amenity for the time share owners. Hoping to add it to the project in the future, Carville renovated the building (as much as possible), adding offices, a hotel check-in, a new copper fireplace and a bar and restaurant that looked out over the waterfall and swimming pool. Now they had ninety one-bedroom suites to sell in an appealing location—without disturbing the parking lot. Preserving its history, Carville called it the Olympic Village Inn.

In 1982, the federal government decided it was time to sell Blyth Arena, so a bidder's auction was scheduled at the U.S. Forest Service office in Nevada City. Once again, the logical purchaser would be Cushing. Although run-down and in need of repairs, the iconic building was surrounded by coveted parking space. Carville and Eureka owned the land surrounding the arena, and it seemed reasonable that they should buy "the hole in the donut," as Carville described it, so they went to Nevada City to bid against Ski Corp., represented by Cushing and Burkhart, and an unknown bidder.

According to Burkhart, Cushing was hesitant about buying the ice arena that he knew lost $60,000 a year, but Burkhart reasoned, "What if someone else buys it and builds condominiums? No more parking!" Burkhart pursued until Cushing was convinced. They decided $650,000 was a reasonable amount.

Burkhart bid $600,000; Carville countered with $650,000. Another man kept upping the bids until they got to $700,000. Carville began to suspect the mystery man was a plant by Cushing. Why would anyone else want the ice arena? Carville called his bosses to see if they could bid beyond their

Blyth Arena. *Photograph by Tom Lippert.*

limit. At $750,000, Burkhart dropped out. Carville, now convinced of what the third man was doing, bid as high as he dared until the man won. Later, Burkhart chuckled when he said, "We put a straw man in there—one of Cushing's lawyers from New York."

With the bad economy and the maligned concept of time shares, sales were hard to come by in the early 1980s. Carville and his wife, Julie, had lived and skied in the area for about fifteen years. They had close ties to the community, and Carville was determined his sales force would not be tainted by the high-pressure sales environment and unscrupulous salesmen associated with time shares. For that reason, he insisted on engaging local realtors and encouraged best business practices. His partner had a different style. Kidwell loved Las Vegas—the shows, the show people, schmoozing with Sinatra and Wayne Newton. When sales slowed in 1983, Kidwell thought Wayne Newton, who had invested in several time-share developments in Las Vegas, could help them improve sales, so he brought him to see Squaw Valley. The following year, he came with an aggressive sales force from Las Vegas. Carville watched in horror as these slick salesmen berated his local sales force for not exerting more pressure on potential buyers. To Carville, they personified everything he detested about the time-share industry, and after weeks of hearing them belittle and degrade his project and principles, Carville fired all the salesmen from Las Vegas, thus writing his epitaph with Eureka Savings and Loan.

The conflict in style and vision for the promotion of their project inevitably led Carville to sell his interest to Eureka in late 1984.

In the mid-1980s, many savings and loan companies went under, including Eureka, which merged into another company whose underwater assets were taken into a Resolution Trust account. The Resolution Trust Corporation hired a consultant to manage the Olympic Village Inn until 1987, when Cushing finally acquired the property and, in exchange for getting total control of the Hub, negotiated an agreement with the property owners association to change the location of the pool and water garden and to build a new covered entrance to the north end.

Ski Corp. removed the tennis courts and established their corporate headquarters in the Hub building. The time-share condos are still owned and operated by the owners, but instead of the pedestrian village Carville envisioned, the Olympic Village Inn today is an island in a parking lot.

# Blyth Arena Down

When skiers and visitors drive up the road into Squaw Valley, the first vision they have is the great wide meadow—green in spring, white all winter. Then they look up to the mountains, perhaps planning which lift and runs they will take. From 1960 until 1983, the next thing they would have noticed was Blyth Arena at the foot of Papoose Peak, where Andrea Mead Lawrence skied down carrying the Olympic torch to light the flame for the opening ceremony of the 1960 Winter Olympics.

Architects Corlett, Spackman, Kitchen and Hunt won first prize over six hundred entries in a nationwide Progressive Architecture Award program for their Blyth Arena design. With no inside supports to obstruct the view, the three-hundred-square-foot roof span sloped up as high as an eighty-story building and opened on the south side, where spectators could view speed skaters on the oval rinks, look up at the seventy- and ninety-meter ski jumps and admire expert skiers swooping down Red Dog.

Built in 1959 for 8,500 people, over 10,000 stood and cheered for the U.S. Hockey Team when it defeated the mighty Soviet Union and went on to win the gold medal match at the 1960 Olympics. Carol Heiss and David Jenkins also made U.S. Olympic history at Blyth Arena with their gold-medal performances in figure skating.

After the Olympics, the bleachers on the south side of the arena were folded back in, and the huge indoor rink echoed with the whack of hockey pucks as amateurs and pros scurried across the ice in practice sessions, summer camps and serious competitions.

When the four-hundred-meter speed skating oval was torn up and replaced with a parking lot in 1963, speed skaters lost the only mechanically frozen track in the United States—a loss for California skaters but a gain for Cushing, who needed the parking spaces. For the next twenty years, Cushing tried to convince the state to tear down the arena.

Charlie Ticknor, Tai Babilonia, Scott Hamilton and Randy Gardner were a few of the many national and international figure skating stars who performed at Blyth. Jimmy Grogan, a U.S. bronze medal Olympian, and his wife, Barbara Wagner, Canadian pairs gold medalist at the 1960 Olympics, ran a popular figure skating program for local children and adults as well as summer youth skating camps. Nightly broom hockey games were also hard fought between teams from ski areas, volunteer fire departments and other local groups.

After the U.S. Olympic Training Center left the valley and moved its operation to Colorado Springs in 1980, the U.S. Forest Service closed the

ice arena for the winter of 1981–82. Still responsible for its maintenance, it brought in "hand crews" of inmates from the California Youth Authority to shovel the one-acre roof—a task that could take up to ten days.

The roof of the arena was not designed to carry a heavy load. Supported by suspension cables strung from sixteen ninety-foot-high columns, it was actually two separate structures designed to flex about twenty inches up or down, depending on the snow load and the temperature. When heat from the ice-chilling equipment traveled up to the ceiling, it was supposed to melt the bottom layer of snow on the galvanized metal roof, causing the snow to slide off into snowmelt pits, which were also heated. This ingenious system broke down some time in the 1970s, perhaps after the outdoor speed skating rinks were removed and the refrigeration method was modified. About that time, the Forest Service began receiving complaints that the roof leaked. Instead of replacing the caulking where the wire rope cables from the columns were attached to the roof beams—a fairly simple and inexpensive repair where the leaks occurred—they accepted a proposal from a roofing company to cover the entire roof with a tar and aggregate mixture. Snow would never slide from that roof again, no matter how high the heat.

Peter Bansen came to Squaw to assist in managing Blyth Arena for the U.S. Olympic Training Center during its tenancy in 1978, and when he learned about the new roof, he wrote, "The acceptance of this proposal indicated a simple lack of understanding of the active nature of the snow load management system of the building and effectively doomed Blyth Arena."

When Squaw Valley Ski Corporation won the bid for Blyth Arena at the auction in 1982, Bansen applied for the job of manager of the building and its skating programs. He was the perfect man for the job. Before graduating from Colorado College, Bansen had worked at the ice rink in Colorado Springs. Already familiar with the inner workings of Blyth Arena, he credits Peter and Dave Onorato, who grew up skiing and skating in Squaw, with assisting him in bringing the arena back to life.

They purchased rental skates and a used Zamboni to clear the ice, repaired the refrigeration system and reinstated popular programs from Tiny Tots in the morning to broom-ball battles late at night. During daily open skating sessions, hundreds of skiers, skaters, locals and tourists returned to stumble or glide around the ice under the cavernous ceiling, where the Olympic scoreboard remained fixed at "USA 3, USSR 2."

During another heavy winter in 1982–83, Bansen and Ski Corp. (as well as many valley residents) watched the snow pile higher and higher on the roof of the arena and wondered if and how it should be removed. Without

the U.S. Forest Service, they had no convict crew to spend a week shoveling. Perhaps they could plow it off with grooming machines. After some careful calculations, they determined that the weight and ground pressure per square foot of the machines was well within the roof's capabilities. Bansen described this experiment:

> *After building a ramp of snow to provide access to the west side of the roof, the first snow cat tentatively crawled onto the roof and began plowing. The distribution of the snow was surprising—it looked to be pretty even when viewed from the ground, but in some areas there were four feet of snow and in others as much as eight. The wind clearly played a major role in this distribution.*

As the winter wore on with snow or rain falling nearly every day from January through March, Bansen reported good attendance and excellent finances at the arena. A movie company was using a number of rooms for their props and equipment while filming the movie *Hot Dog* with local skiers.

On March 23, Bansen went to the building at 6:00 a.m. to pick up the cash from the previous day and take it over to the Ski Corp. offices in the tram building. When he returned, an unexplainable instinct caused him to look up at the ceiling. As his eyes followed the conduits that were fastened to the side of a beam in parallel stacks, he saw something that didn't look right. "Instead of being in a neat, vertical stack, the upper conduits in the stack were bowed out, away from the beam," he wrote later.

On further inspection of the beams, he found more alarming signs. In need of a second opinion, he brought assistant manager Jimmy Mott to the scene, and together they looked up at the giant roof above them. Jimmy confided that he couldn't see anything amiss and told Bansen to do what he thought best.

Bansen decided to close and clear the building. The thought that "Maybe nothing would happen, and I'd look like an idiot for thinking anything was wrong," prompted Bansen not to say why he was closing the building. To discourage the movie crew from working that day, he turned off the power and told them there was a power failure. To ensure that none of his staff, who had keys to the building, would enter, he changed all the padlocks on the doors back to the old Forest Service locks. He then went outside and walked around the building. "To my horror," Bansen wrote, "the lower cables supporting the two beams that were deflecting were starting to fail. I could see several broken wires hanging out of the cables already, and periodically another would break with a chilling flat twang."

Now more convinced than ever that something bad was happening, Bansen returned to Mott for a solution. He wondered aloud if it might be too risky to put the groomers on the roof. Perhaps he should activate the roof heater—although he didn't believe that would really help. Once gain, Mott replied, "Do what you think best."

Bansen walked back across the parking lot, wondering what he could do to save the arena. He describes what happened next in his report:

> As I got about halfway across the lot, there was a resounding boom, and the center section of the east side of the roof collapsed. A huge cloud of dust rose out of the arena, and I remember seeing the west side roof bouncing up and down as it rebounded. Around me in the parking lot I could see people turning toward the source of the sound and screaming. I was horrified, but my immediate emotion was one of relief; the waiting was over.

Bansen returned to Mott's office to tell him what happened. He then paged the fire department and returned to the back gate to meet them.

Relieved to find Bansen on the outside and not under the rubble, the fire chief asked him, "How many people do you think are in there, Pete?" "There was no one in the building," Bansen replied. "It was closed and locked up when the collapse occurred."

The building was removed in 1983. Cushing got his parking lot, as well as twice the amount of insurance on it as he had insured it twice (inadvertently, according to Burkhart).

Pete Bansen, always a volunteer fireman, went on to become fire chief of the Squaw Valley Fire Department.

# THE DAY THE MOUNTAIN CAME DOWN

Anyone sleeping in or near Alpine Meadows or Squaw Valley might have thought the two areas were at war when they awoke the morning of March 31, 1982, to the constant "kaboom" of 75mm howitzers and recoilless rifles blasting at the ridges and bowls above both areas.

Vacationing skiers, held under house arrest by a relentless storm that had dumped eight feet of snow on Sierra ski resorts over the last five days, brewed their coffee and turned their TVs or radios on, hoping for news of a let-up only to learn there was none. Roads were clogged—many of them were closed.

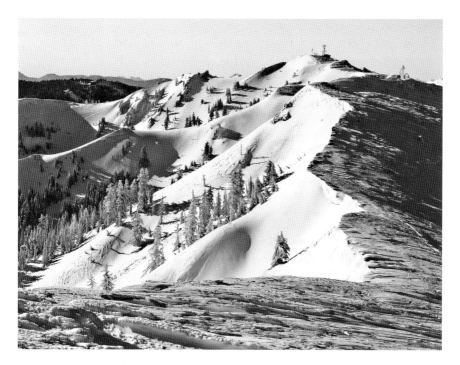

Estelle Bowl (where avalanches are born) looking south to Ward Peak in Alpine Meadows. *Courtesy of Alpine Meadows.*

Those who had to go to work—or just couldn't stand it any longer—dug their cars out from the three feet of snow that had fallen overnight. As they tossed the snow high onto surrounding banks, they might have noticed how quickly and lightly it slid back down and how, when they slammed the door of the car or house, small surface slides on six-foot snow banks along driveways and roadsides came down all around them.

If they went to ski or to work that morning at Alpine, they would have been stopped at the edge of the parking lot by a road guard put in place by Bernie Kingery, Alpine's mountain manager. Having spent the last three nights up at the mountain, Bernie had called general manager Howard Carnell at three o'clock that morning to report high winds sixty to one hundred miles per hour on the summit and sixteen inches of new light snow falling at approximately three inches an hour on top of a heavier pack. At 7:00 a.m., they decided not to open the ski area.

A few feet from Alpine Meadows lodge and just below the base station of the Summit chairlift, the Summit Control Building houses the ski school, ski patrol, lift operations and avalanche control headquarters (also known as

Base 4) with a locker room and offices for managers and storage for uniforms and rescue equipment. From inside this building, Kingery monitored wind velocity on his anemometer, snowfall and the locations and actions of his snow safety operators.

Earlier that morning, patrolmen had gone out in teams of four to shoot or throw charges at known avalanche paths. One team brought down a class-four slide under the Scott chair, where two groomers had been buried in an avalanche in 1974. Another team shot explosives at Wolverine and Beaver Bowls, where a slide had killed three in 1976. With the wind whipping the snow in billowing sheets across the landscape and in their faces, they couldn't see or hear if they succeeded to bring down any slides. "With this much snow, the surface bombs may not have as great an effect on the deep slabs, and Squaw's been reporting four- to five-foot slabs," patrolman Gary Murphy was quoted in an article by Steve Casimiro in *Powder* magazine.

With no lifts running to transport them to the mountaintops, the team focused their attention on the Buttress and Pond slopes above the parking lot, firing shots high and in the center. When nothing moved, they considered the parking lot safe. Although Placer County had not officially closed the Alpine Road, Bernie ordered everyone not involved in avalanche control to leave the area. He also notified the Alpine Chalet at the far end of the parking lot to advise guests in the condos to stay inside. By early afternoon, Alpine was deserted, except for seven mechanics in the maintenance garage, a few lodge employees and assorted patrolmen assisting Bernie.

Parked close to the maintenance building, where he had lived for the past ten years, John Reily, seventy-four, listened to the muffled booms of the hand charges from inside of his motor home.

At 3:00 p.m., Larry Heywood, assistant ski patrol director, and Jim Plehn, avalanche forecaster, left with three patrolmen and a driver for Squaw Valley, where they would take the KT-22, ski over to the ridge and throw charges on to the slide paths that threatened Alpine Meadows Road. As they drove through the empty parking lot, they saw people brushing snow from buried cars and walking through knee-deep snowdrifts. Two cross-country skiers were coming up the road, apparently heading for the lodge, and what appeared to be a family of three, heads down in the blizzard, shuffled through knee-deep snow, also in the direction of the lodge. As the men left the parking lot, they pointed out little surface slides on every ridge and gully—it was as if the snow were alive. They looked forward to launching a big one that would cover the road.

When Anna Conrad and her boyfriend, Frank Yeatman, finally arrived at the Summit Control Building after having cross-country skied all the way from her house in Alpine Meadows, Kingery was furious—didn't they know the area was closed? Couldn't they see how dangerous it was to be here? Was it worth risking their lives just to get something out of her locker? Couldn't it wait? Anna muttered that the road was still open and then retreated to the locker room.

Beth Morrow hunkered down at her desk to log the events of the day while Jake Smith bundled up to go out on a snowmobile to keep traffic off the road when the men started shooting from the top of KT. As he left the building, Randy Buck, Tad DeFelice and Jeff Skover came over from the main lodge to receive instructions for guarding the road.

Following Kingery's advice to leave the area before they shot the road from Squaw, Howard Carnell left twenty minutes later. On the way out, he saw Jake on his snowmobile at the entrance to the parking lot, where the road branches to the Alpine Chalet, and he waved at the others guarding the road below the parking lot.

Kingery, staying close to his radio, got a message from Squaw that his crew had arrived and was preparing the equipment before loading the KT lift. He told his men to have the driver wait for them. Five minutes later, he got another message from Smith in the lower parking lot. It was a muffled warning: "Avalanche!" Kingery asked his position but couldn't hear an answer. Buck, DeFelice and Skover watched Kingery pace back and forth with his radio at his ear.

Then the lights went out. The building began to rumble and shake and then exploded as a hurricane-force wind plied the entire structure loose from its steel and concrete foundations and blew it into space, along with Morrow and Kingery. Seconds later, the avalanche hit. Buck covered his face and curled up into a ball. Skover, fearing it was an earthquake, dove under a counter. Both men were tossed and tumbled in a washing machine of snow, furniture, branches and building parts.

As the snow settled over the debris, tightening its glacial grip on its victims, Buck managed to find a floor under him and air above and struggled out of his icy tomb. He didn't know then that he had a broken rib and had a compression fracture in his back. Tad was close by but stuck from the waist down. As Buck confirmed that Tad was unhurt, a few men from the maintenance shop arrived to help dig him out. Then they left the shattered remains of the building and commenced searching in the avalanche debris for Bernie, Morrow and Skover. They found Skover under a foot of snow,

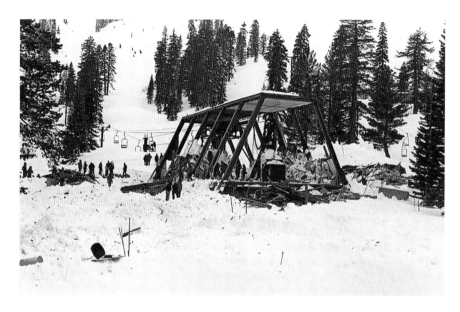

Summit control building after the avalanche at Alpine. *Photograph by Tom Lippert.*

covered with a sheet of plywood. He was unconscious but miraculously alive to tell the tale of his high-speed tumble through snow, wind and flying objects to where he had landed near the ski school bell. There was no sign of the other two.

At the same moment the avalanche hit the Summit Building, the sound of breaking trees and cracking branches sent the maintenance men out from their garage to watch a tsunami of snow engulf the parking lot and mow down three figures running for their lives before its white peril. From their island of safety in front of the garage, the men gaped in horror as twenty feet of snow mixed with trees, stumps, branches, telephone poles, wires and debris buried the three figures and all the remaining cars in the parking lot. Mike Alves and the maintenance crew grabbed shovels and probes, rounded up all the help they could find and began searching in the area where he had seen three people disappear. With all of the rescue equipment swept away with the Summit building, they would have to improvise. They grabbed whatever was long and thin from the shop.

John Reily, waiting in his mobile home for the lights to come back on, finally stepped outside to see what was happening. With no lights on anywhere, he gasped at the sight of his once familiar parking lot, now unrecognizable, ominously silent and buried under ten feet of snow and avalanche debris.

Howard Carnell was about halfway down Alpine Meadows Road when he received a call on his radio from Karen Strolmeyer on the switchboard at Alpine telling him an avalanche had struck the lodge. He turned around and headed back up to the area. When he reached the parking lot, he looked across six hundred feet of avalanche debris to the maintenance garage and estimated that several acres of snow ten to twenty feet deep blocked all access to the main lodge. On his way back down the road, he encountered a Placer County road grader and called the sheriff's department on his radio.

Larry Heywood and his crew were about to get on the KT-22 lift when the lift operator told them there had been an avalanche in the residential area in Squaw. Apparently, a man had stepped out of the shower and found that half of his house had been swept away.

When their walkie-talkies began to crackle, the men picked up Howard Carnell's voice requesting dogs and ambulances. Wondering what was up, they tried to call Bernie at avalanche control headquarters or anyone they knew with a radio. No answers. Finally, using a telephone provided by the lift operator, they reached ski patrol director Bob Blair, at his home in Alpine, who told them to return to the ski area.

Blair was waiting for them in Carnell's car, and at last they got the whole story. With Bernie missing to lead the rescue operation, the access road to the area more dangerous now than ever, the parking lot impassable, snow accumulating and darkness approaching, a plan evolved.

Blair and Billy Patterson, one of the groomers who had escaped the area over the avalanche in a snow cat, would open a road through the Bear Creek subdivision to the southern edge of the parking lot. Carnell joined the patrolmen and volunteers who clamored aboard the snow cat. Other volunteers grabbed a rope behind and hung on for a wild ride up and over the avalanche into the foreboding gloom of the devastated ski area. When they saw Jake Smith's snowmobile lying crushed in the snow, two men dropped off to search. Joined by an army of volunteers armed with shovels and ski poles, they dug and probed frantically until they found Jake's body in a creek bed under the chalet bridge. "He must have seen the avalanche coming and run for the bridge," Carnell told his friends later.

The group reached the parking lot just when Mike Alves and searchers from the maintenance garage located David Hahn, a member of the family they had seen running from the avalanche. After a difficult extraction from ten feet of snow, his body was carried to the first aid room in the lodge, where wind and snow blew through the broken windows. By nightfall, Bud Nelson, also dug up from the parking lot, would join him.

Carnell set up his control headquarters at the bottom of the Alpine Road in the Water District Office, as Tahoe Nordic Search and Rescue volunteers, patrollers from Squaw and other areas, fire departments, California Highway Patrol officers, Placer County deputies and a band of local volunteers assembled to launch a rescue operation.

Larry Heywood took over the search operation up at the Summit Building with the urgent mission of finding Bernie Kingery, Beth Morrow, Anna Conrad and Frank Yeatman. During the process, he learned that the big bowls on the mountain had not avalanched, ratcheting up the sense of danger shared by every rescuer on the scene. With snow falling heavily, little hope of finding anyone alive and the possibility of another avalanche ending the whole operation, the search was suspended. Exhausted, frightened, cold and, in some cases, traumatized, everyone was out of the area by 11:30 pm.

The next morning, April 1, looked hopeful, with a blue sky and the sound of helicopters dropping charges above the road and artillery aimed at the slopes above the rescue site. With a clearer view of the devastation, the search resumed. Laura Nelson's body was found in the parking lot. Anna Conrad's friend Frank was found in the wreckage of the Summit Building, while Beth Morrow's body was recovered from beneath the debris nearly one hundred feet from where she had stood by the window with Bernie.

Larry Heywood describes the challenges of the search in his report written for *Avalanche Review* (a publication of the American Association of Avalanche Professionals): "Since probing around the Summit Building was impossible due to all of the debris from the building, trenching with snowplows and shovels was employed. Chain saws, wrenches and cables were used to gain access into the destroyed building." In spite of these efforts, Bernie and Anna were not found on day two, as increasing avalanche danger and impending darkness forced the rescuers to leave by 6:00 p.m.

On Friday, day three, patrolmen continued to bomb and throw hand charges above the road and on the bowls above the ski area, but nothing came down. Snow continued to fall in record amounts, and everyone left the area by one o'clock. For two more days, snow fell and the area remained too dangerous for further rescue attempts.

At last, on Monday, April 5, the storm abated, allowing the helicopter and artillery to resume bombing, opening the road and making it safe for the rescuers to return to the Summit Building, where they went to work with anxious determination. When a hand moved in the snow, elated rescuers called out, "Anna, is that you?" Her reply, "I'm O.K. I'm alive," brought hope, joy and renewed energy to the team as they called in the helicopters to

lift her out from a space beneath a fallen metal locker where she had spent the last five days. An hour and a half later, Bernie was found far from his desk, phones and rescue station. The search for survivors was over.

During the week of this lethal spring blizzard, one hundred people were evacuated from homes in Alpine Meadows. Two hundred were evacuated in Squaw, where a steep northwestern ridge slid into two homes. Most evacuees stayed with friends in the area.

John Reily was taken to the Tahoe Forest Hospital in Truckee for observation, where he told reporters he was fine—"just luxuriating in the hospital until the storm quits."

Alpine season pass holders were invited to ski at Squaw until Alpine could repair the lodge and two lifts and reopen.

# A White Wolf's Tale

Troy Caldwell was nineteen years old when he came to Alpine Meadows in 1970 and got a job selling tickets while he perfected his freestyle technique on the slopes of Alpine. By 1972, he had joined the international circuit on the U.S. Freestyle team and was competing with Poulsen Wong, John Clendenin and local pal Rudy Zink. Early in his career, he met his future wife, Susan, who happened to live nearby in Homewood, and before long, she also began working at Alpine.

Troy, having studied architecture in college, worked as a contractor in summer months. By 1989, he had built two houses in Alpine Meadows, renting one and living in the other. Susan, now in charge of special tickets, knew every season pass holder, former stockholder and just about every regular customer at Alpine by their first name, and her smile and effusive greeting typified the friendly face of Alpine. Like many young couples who love to ski and love the mountains, they began to think about owning their own business, and they decided that a bed and breakfast in Alpine, which had no overnight accommodations, would be a good idea. "Something fancy, like Stein Erickson's Lodge," Troy thought. "Me and Susie would serve them at the bar, entertain them. We'd have a little ski shop and a surface lift to take them to Alpine," he added, reminiscing about their original plan.

They thought a good location would be just above the road before you enter the parking lot. Troy discovered the land was owned by Southern Pacific Land Company (SP), so he dressed in his very best "mountain attire"

and went to their office at One Market Street in San Francisco. "When I looked up at those two fourteen-foot chrome doors, I said, 'What am I doing here?'" Troy remembers.

More determined than daunted, Troy introduced himself and was ushered into Brandon Mark's office. "I know you guys own the property next to Alpine Meadows," he began, "and I'm interested in buying a little corner of that property."

"Well, there's good news and bad news," Mark replied. "Bad news—we can't sell you a little piece of that property. We're not allowed to sub-divide it. The good news is that your timing is great. Right now we are in negotiations with Catellus to get rid of all of SP's property, and anything we can sell outright before any transaction with Catellus is money in our pocket."

Mark showed Troy a map of SP's holdings in California—a well-documented checkerboard of land the railroad company bought from the federal government in the 1800s. It just so happened that in 1987, SP began selling off large tracts of land in North Lake Tahoe—and in walked Troy Caldwell.

When Mark showed Troy a 144-acre parcel of land in the lower section, Troy said, "No way can we afford that." But Mark urged him to consider it. "You may be surprised," he said.

Before they had time to think about how they could afford the 144-acre parcel shown on the Placer County map, the county advised them it wasn't a true parcel. The only thing SP could sell them was the whole 460-acre section—the same section John Reily had leased from SP in 1958 and then relinquished in a quitclaim in 1975. "No way can we afford that," Troy repeated even louder. "What happened to our dream of a bed and breakfast for forty to fifty thousand?" Susan asked. "Now we're talking hundreds of thousands." "This is worth it, Susie. Let's go for this thing," was Troy's reply.

For obvious reasons, Cushing had been waiting for years to own the land under his lifts that he had been leasing first from Reily and then from SP. During that time, Cushing had bargained over the terms of the lease agreement with SP for years, and the company was well aware of his interest in acquiring the land. Therefore, when SP called Squaw Valley Ski Corp. to inquire if it would like to purchase Section 5, which included the seventy acres in Squaw Valley, they must have been surprised when the accountant who took the call said, "No thanks. We rent it so cheap I don't think we're interested."

However, no one could have been more surprised than Cushing when SP notified him the following month to send his next rent check to Troy

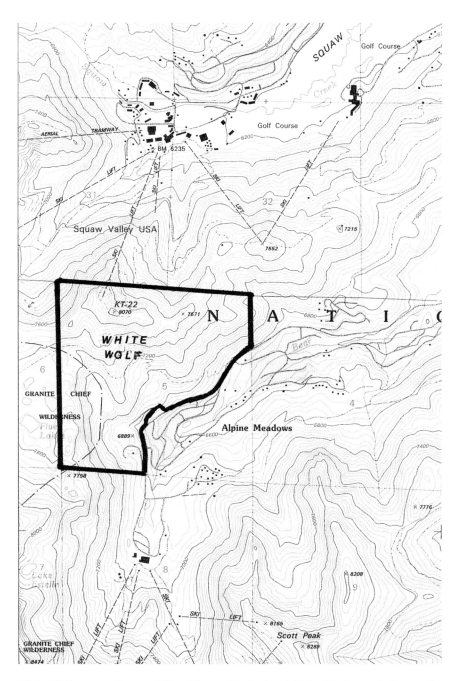

White Wolf on map showing KT and Squaw lifts (top) and Alpine lifts (bottom). *Courtesy of Troy Caldwell.*

Caldwell. "Who is this guy?" Cushing asked when he called Nick Badami at Alpine. Badami assured Cushing that Troy Caldwell was not a real estate developer, just a young freestyle skier with big ideas. So Cushing called Troy and invited him to lunch.

According to Troy, it was a pleasant, friendly lunch, and Cushing listened with interest (perhaps disbelief) to Troy's story about why and how he bought the land out from under Cushing for just under $400,000.

Troy and Susan call the next four years their "Daniel Boone years," as they struggled to build a road and move their trailer from the campground to their property before winter set in. An early October snowstorm caught them with frozen water lines running from a spring over the snow to the trailer, a generator that ran out of gas in half an hour and an oven big enough for only a cupcake. During those four years, they began to build their house on a flat area at the base of KT's backside. Although Larry Heywood had checked the area for avalanches, they weren't sure it was safe—but they knew enough to get out if danger seemed imminent. Troy remembers digging down eight feet to the top of his trailer. "We were just surviving," Troy recalls. "No water, no power—sometimes the only vehicle we could use was our bulldozer."

When summer came, thoughts returned to what they would do with their property, now called "White Wolf." In an effort to get Alpine involved, Troy invited Nick Badami, Howard Carnell and Werner Schuster to a catered lunch served under the pines by the creek near his future home. Badami and Schuster were currently involved in developing a new ski area at Galena Summit near Reno, where Troy and Susan had considered owning and operating a bed and breakfast. But after attending months of public meetings, Troy picked up on the sentiment, "Why develop new areas? It's better to expand the existing ones." Troy could see the logic and said to Susan, "Hey, why not here in Alpine?"

Badami suggested a "Fat Camp," a spa with outdoor exercise, or a rock-climbing camp. He and Schuster thought perhaps the area could connect to Squaw Valley, and they wondered about the increased traffic in Alpine.

The realization that 460 acres of granite cliffs, stately pines, chutes and gullies, steep and gentle slopes, mountain trails and wildflowers galore in the spring was perhaps worthy of something more than a little bed-and-breakfast inspired Troy and Susan to expand their dream to a fifty-two-room luxury hotel. Of course, Troy would design it in his favorite architectural style—avalanche and fireproof concrete. Then, with Troy thinking really big, a ski area in his front yard seemed like an even worthier project.

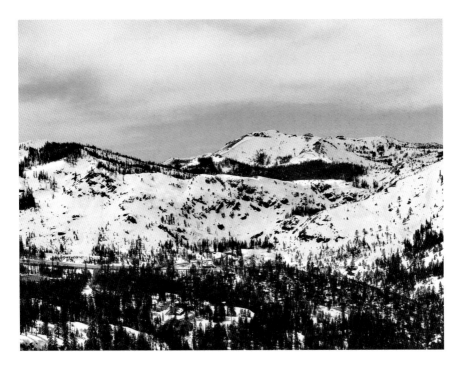

View across Alpine Meadows Road to White Wolf. *Courtesy of Troy Caldwell.*

Like Poulsen, Reily and even Cushing before him, Troy Caldwell had realized a dream that would be his life, with many unexpected consequences (and a few nightmares).

It was only a matter of time until Cushing called his landlord to renegotiate the terms of the lease that Troy had inherited from SP. Although the termination date, 2014, was about eight years in the future, Cushing wanted to get started on a new lease now. Troy, still unsure of his future plans for a ski area at White Wolf, didn't want to sign anything just then. In 1996, after recalculating their agreement, Cushing filed a suit for breach of contract, claiming he had "overpaid" on his lease.

While Troy hired and paid lawyers to work on that one, the two men entered in to an agreement to trade seventy acres of Troy's land in Squaw Valley for the three-year-old Headwall triple chairlift—towers, chairs and cables—to be delivered over the hill by helicopter for Troy to install on his side of KT. Cushing would have his land back and Troy his lift. However, after signing the contract, Cushing decided that it was too good a deal and changed it to the thirty-year-old double Cornice chairlift. Troy sued Cushing for breach of contract.

When the Placer County Planning Commission issued the Caldwells a conditional use permit to install a chairlift on their land in November 2000, Troy bought the old KT lift for $150,000 and then went to work reassembling and altering it to his specifications in his garage cum-lift manufacturing plant with the help of a welder who once worked for Doppelmayer and a chairlift engineer formerly employed by YAN Engineering. While they worked in the garage on the seventeen towers, cross frames and terminals for the next nine months, few people knew what Troy was doing. But as soon as the towers could be seen climbing 1,123 feet up the mountain from Alpine to Squaw, heads turned, and the Bear Creek homeowners sued Placer County for issuing Troy the permit. That one hurt, as Susan had worked for over twenty years in Alpine and they both considered themselves members of the Alpine community.

The Caldwells compromised with Bear Creek and the ski area, agreeing that they would not sell tickets and that access from Squaw Valley would be denied. Further restrictions allowed them only twenty-five "friends or family" on the mountain at a time, and skiers had to take a first aid course and be avalanche certified, carrying beacons, probes and shovels.

With these restrictions, White Wolf became the second private ski area in the country after the Yellowstone Club in Montana. Operating his area much like a heli-ski operation (without the fancy lodge—yet), Troy's many super-skiing friends have joined him on snow cat rides up the mountain, descending in a spray of fresh powder or exploring the terrain on firm spring corn. With its southeast exposure, the season is limited in comparison with that of neighboring Alpine Meadows.

Troy won his suit over the exchanged ski lift with Cushing, and after fourteen years of trying to bring the young entrepreneur to his financial knees, Squaw Valley Ski Corp. relented. Troy believes they were preparing to sell Squaw Valley and needed to get rid of what Troy's attorney called "nuisance suits."

With no more legal battles, a cozy home and towers in place, Susan and Troy's dream was just beginning.

## Chapter 8

# LAW, LOVE AND LAND

## CRIMES AND MISDEMEANORS

When the snow melts in spring from the slopes above Shirley Lake in the high northwest reaches of Squaw Valley, it trickles down into the lake, pours over giant boulders, lingers in deep pools and then rushes down Shirley Canyon, where it splashes its way to the valley floor and begins its purposeful meander through the meadow and into the Truckee River. Anyone who has spent any time in Squaw Valley has probably hiked up the Shirley Canyon trail, marveled at the variety of wildflowers, stopped for a cold dip under a waterfall or a picnic at "flat rock." Slabs of granite polished smooth by glaciers entice climbers to clamor up and slide down their steep sides.

For many Squaw Valley residents, an evening hike up the canyon was (and still is) a weekly—even daily—ritual, so it was no wonder they were dismayed in 1972 when they learned that Placer County had adopted a Squaw Valley General Plan in which Ski Corp. intended to build a number of lifts at the head of the canyon. Alarmed at the possibility their special place would be transformed from a mountain retreat to a bulldozed ski run, cries of protest were heard at meetings and in letters to the editor of local papers.

Placer County took the position that the Shirley Lakes area was an environmentally sensitive area bordering the Granite Chief Wilderness Area and therefore was best left in its natural state. If used for cross-country or "glade" skiing, minimal tree cutting and no trail grooming would be necessary.

After much maneuvering among the Ski Corp., the public and the county, a Squaw Valley Master Plan was released in 1975 in which Ski Corp. was granted a conditional use permit (CUP 067) to build the Silverado Lift above Shirley Lake. Described as a "ski through the trees" kind of experience for expert skiers, only ninety trees would need to be removed. No trail clearing would be necessary, nor would there be a need to build access roads for construction or maintenance.

A year later, Ski Corp. requested an amendment to the master plan and another CUP (095) to build another lift (Solitude), also above Shirley Canyon. During the summer of 1977, construction began on the 2,600-foot-long Solitude lift and continued until September, when Placer County officials issued a stop-work order for what they called "willful violation of a number of conditions"—i.e. "blasting a road so heavy construction equipment could do work which was supposed to have been done by helicopters" and endangering Shirley Lake by "anchoring the lift in its fragile marsh land" close to the lake.

In what some might call typical "Squaw Valley Style," the stop-work order was ignored. A restraining order was issued by a judge, but another judge dissolved it.

Responding to the opinion of county officials that construction of the lift was "environmentally damaging," Cushing wrote in his 1978 annual letter to season-pass holders, "Placer County said the operation of this lift would have an adverse impact on the environment. Maybe I am not in tune with the times, but I have never thought there was any conflict between the 'environment' and skiing—it seems to me they complement each other."

Reactions from other Ski Corp. employees were quoted in an article in the 1977–78 edition of *Skier's Almanac*, a publication of the Far West Ski Association: "John Buchman, president of the Squaw Valley Corp., said he could not understand why 'one can't do with one's property what he pleases.'" Hans von Nolde, photographer and unofficial PR representative, was quoted as saying, "Long-haired nature freaks are helping to bring an age of socialism to the country." Adding to the spectrum of opinions, the article quotes a county official describing Cushing in the *San Francisco Chronicle* as "an imperious son of a bitch," while another official acknowledges that "Squaw Valley wouldn't be the major resort it is if it weren't for someone like Cushing."

The Solitude lift opened in April 1977 at the close of one of the worst ski seasons on record.

Ski Corp. requested a renewal of the expired CUP (067) for the Silverado lift in 1982 with an amendment to expand the lift capacity from double to

triple chairs. The county approved their request with the stipulation that the terminal be moved away from the north fork of Squaw Creek and the hiking trails of Shirley Canyon.

In 1983, the county updated the Squaw Valley General Plan, and a new environmental impact report (EIR) noted increasing environmental issues in the valley, including "traffic congestion, water quality degradation and air pollution from heavy traffic days." To preserve the environmental integrity of Shirley Canyon, the county zoned the area in which the Silverado lift was to be constructed as a "conservation preserve." This zoning does not permit construction of ski lifts or trail clearing—bad news for Ski Corp. The county tried to convince Ski Corp. to use their lift permit in another area, but Cushing was a stubborn fellow. He was determined to expand the ski area at "el. 8,200," and he did have the 1982 CUP to build his lift. Cushing declared that the rezoning denied him the right to use his property without compensation, so he filed a suit against the county and began construction on the lift in 1984.

Perhaps seeking an escape from an expensive and contentious legal battle, Ski Corp. applied for an amendment to the 1986 general plan to rezone 230 acres of land in the Shirley Canyon area from conservation preserve to forest recreation (skiable). Included in the amendment was a CUP to clear trails served by the Silverado lift and a permit to remove 1,858 trees. This plan was made public in April 1988, and after two years of heated debate, a hearing for approval by the board of supervisors was scheduled for July 25, 1988, in Auburn.

As the date neared, letters to editors at local papers voiced general disapproval. Elizabeth Rogers wrote:

> *When Alex Cushing received the CUP to build the Solitude and Silverado lifts, he maintained that he only needed to cut 90 trees for the Silverado lift. Now he is asking to cut 1,858 trees over 6" in diameter—for skier safety. Will his next request be a ski run down Lower Shirley Canyon, for skier safety? He says he has no plans to do this. Can we believe him?*

Rogers claims that over two hundred letters had been sent opposing tree cutting. Jim Mott, president and general manager of Ski Corp., responded to her letter, saying, "In 1982, an agreement was worked out with Placer County so that the lift would not impact the north fork of Squaw Creek, the waterfalls, or the hiking trails in Shirley Canyon," and he assured her that in compliance with the terms of the agreement, the lower terminal had been

moved "away from those areas." Mott goes on to pledge, "None of the tree cutting will take place in those areas of Shirley Canyon described by Ms. Rogers. The majority of the tree cutting will take place in the bowl beneath the cable car just before it reaches High Camp—an area far removed from the areas of waterfalls and hiking trails."

Ken Heiman had covered the story for the *Tahoe World* for the past three years, and in an article published the day of the hearing, he quoted Mott expressing his frustration: "If the supervisors don't approve the plan amendment, we'll activate the lawsuit to develop our land—that's not a threat, and it would be our least desirable option."

After a day of testimony and debate and despite an initial recommendation by Placer County to deny the request, the board of supervisors approved the zoning change, the CUP and the general plan amendment by a four-to-two vote.

Larry Sevison, one of the supervisors in favor of the amendment, was reported as suggesting that "environmental impacts could be sufficiently mitigated under measures suggested by county staff," adding that Glen Smith, a registered forester and project manager, could help in that effort.

After receiving authorization to cut the trees in October, the California Division of Forestry suggested to Smith that Ski Corp. could sell the felled trees instead of leaving them on the ground to be collected for firewood. Ski Corp. then amended their plan for timber management to one that allowed them to sell the trees. The permit was allowed in December 1988 after Mott signed an affidavit that the conversion of the land in question would commence in April 1989.

When the Sierra Club got wind of the plan, they filed a suit to set aside the EIR and all approvals, and a court hearing was set for January 31, 1989. Since Ski Corp. didn't intend to cut any trees until April, the court saw no reason to issue a restraining order until later that year. That allowed Mott and Smith to submit the required forest harvesting plan to the California Division of Forestry in time for their April operation, assuming the Sierra Club didn't throw a chain saw into their plans.

In testimony at trial and later recorded in the news, a Squaw Valley employee reported overhearing Cushing say to Mott, "We have a very short time frame here. We have the legal documents to proceed on this. Let's get these things cut. What are they going to do—make us replant them?"

When Mott told Smith that they planned to cut trees, Smith advised him to wait for the timber harvesting plan to be approved and that cutting them now could incur legal ramifications.

On the weekend of January 28 and 29, 1,800 trees were clear-cut in the Shirley Lake area without the required presence of a registered forester. Local papers reported some of these trees were three hundred to five hundred years old. When Glen Smith arrived on the scene, he found the cut logs piled in an unapproved area where they could not be removed without road construction—an additional infraction.

Having violated the requirements of the pending application for a harvest plan to commence in April, Smith tried to convince Mott he must abandon their plan to sell the timber and cancel that application. Mott held firm until Smith removed his name from the application, and the Division of Forestry called Mott and requested that Ski Corp. cancel the application to sell the fallen timber.

When the Sierra Club learned of the tree cutting in January, they applied for a temporary restraining order on further tree cutting in Squaw Valley, and Judge Garbolino granted it. Nevertheless, more trees were cut in March of that year. Although they were outside of the CUP area, they were inside the area of the restraining order. That got the attention of William Hewlett, co-founder of Hewlett Packard and a landowner in the county. An amended complaint was filed with the Sierra Club, Hewlett and Placer County (in the name of the People) for "unfair competition" that alleged the Ski Corp. had violated the Forest Practice Act by cutting the trees in Shirley Canyon before April (as specified in the plan), cutting without an approved plan and cutting the trees without first notifying the Division of Forestry. Further allegations included Ski Corp.'s violation of the CUP conditions by failing to have a registered forester present at both the January and March cuttings and failure to remove the trees to an approved landing area. The March cutting violated the Temporary Use Permit.

In his March 1994 letter to Squaw Valley skiers, Cushing pleaded his case:

> *The environmentalists, having been unable to thwart the development of Squaw Valley, have decided to go for the jugular—eliminating Ski Corp. entirely. What is different this time is these dissidents have latched onto some real money in the person of "Billionaire Bill" Hewlett of Hewlett Packard and the Sierra Club, both of whom are somehow bound in an unholy alliance with the Placer County D.A. This unlikely but powerful cabal seeks not only to dismantle both the Silverado and Broken Arrow lifts but to destroy Ski Corp. by putting it into bankruptcy through the levying of fines and legal costs approaching 14 million dollars.*

He goes on to say, "Arguing over the cutting of certain trees, which is essential for the safety of our skiers, is a dispute from which only the lawyers can gain. A ski area and a wilderness area are quite different. Squaw Valley is not now a wilderness area and never will be."

In October 1994, the court concluded that Squaw Valley had violated the Forest Practice Act by conducting timber operations in 1989 and 1992 without an approved timber-harvesting plan. They had violated both the CUP conditions and the Temporary Use Permit. Cushing and his lawyers responded with a long list of appeals, which were argued and analyzed for months. In the end, the court wrote the following:

> *Squaw Valley next contends the injunctive relief is unrelated to the proven violations. Nothing could be further from the truth. The record is replete with evidence of Squaw Valley's complete disregard for procedures designed to protect the environment and forest resources. Its focus was on developing a ski run for the Silverado lift as quickly as possible, without regard to permit requirements or court orders. The fact that a hearing was pending on an injunction to preclude further cutting spurred Squaw Valley to advance its plans and fall a large number of trees. Squaw Valley's cavalier attitude led to the cutting of more than 1,800 trees, many of them hundreds of years old, without the proper FPA permits, without a valid EIR, and without an approved use permit.*

Throughout the 1990s, Placer County officials, the Lahontan Regional Water Board and environmentalists kept a host of lawyers busy (and rich) with tree-cutting incidents, restraining orders, controversy over widening the road into the valley, complaints of excessive noise from snowmaking, an accidental forty- to fifty-gallon diesel spill in the parking lot and a $43,000 lawsuit lost to Bud Hoffman, owner of Any Mountain Ski Shops, over a land dispute.

Relentless in their pursuit of environmental misdeeds, the Environmental Protection Agency (EPA) executed a search warrant at Squaw Valley's corporate offices in search of federal Clean Water Act violations, and on June 20, 2000, armed federal marshals scared the hell out of everyone present as they carted off filing cabinets and computers.

# DAMN THE TORPEDOES

Hans Burkhart returned to Squaw Valley in 1998 to build the Swiss-manufactured Funitel lift with help from his good friend and electrical engineering genius Hardy Herger. "We finished in eighteen months," Burkhart recalls with pride. He worked with a crew of fourteen Mexicans, "sometimes until 10:00 p.m. [and] on weekends." He adds, "They were always there—no excuses, totally dependable. Couldn't have done it without them."

When Burkhart prepared for a test run, he discovered the gondola cars did not clear the lip of a rock outcropping—a miscalculation by the engineers, he surmised—so he went to discuss with Cushing a request for new calculations, revised drawings and permits. Experts claim it was likely they would have obtained the necessary permits but not in time to open the much-advertised new lift for the Christmas holidays.

"Alex said, 'Oh the Hell with it. Just blast it.' So I did," Burkhart recalls in an interview.

Late that night, a resounding boom echoed from the peaks and rumbled through the valley. It would be Squaw's last illegal blast, unleashing an avalanche of allegations led by the Lahontan Regional Water Quality Control Water Board and Placer County, who had already slapped Ski Corp. with stop-work orders at various times during the Funitel's construction.

In making their case on January 4, 2002, that Ski Corp. "submitted incomplete, inaccurate or misleading CEQA information to government officials," Lahontan alleged that in obtaining permits to build the Funitel, Ski Corp. had "described the project to county and state officials as involving minimal excavation, minimal alteration of terrain, and minimal disturbance of vegetation." In reality, however, "the project involved blasting and excavating thousands of cubic yards of material, reshaping a ridge, cutting numerous trees, and burying other vegetation."

Other misdeeds listed in the suit included, "backdoor trail blasting" to the base of the Solitude Lift, expanding the "Ho Chi Minh" trail without a permit, illegally modifying existing trail drainage, improperly constructing and replacing a drainage culvert, not removing two lifts in a timely fashion, an underground storage tank and using water from Gold Coast pond for snow making and not for irrigation, as agreed.

In his letters to his "faithful" Squaw Valley skiers, Cushing often vented his frustration with what he perceived as regulatory overreach and unreasonable

environmental demands, reassuring his readers with his favorite naval expression: "Damn the torpedoes, full steam ahead." Perhaps this time the torpedoes hit their target—but they didn't sink the ship.

*It is easier to beg forgiveness than to ask permission.*

## The Bear Goes over the Mountain

With no lawsuits to divert funds from investing in infrastructure, Alpine Meadows spent $30 million in the years 1988 to 1993 on snowmaking, grooming equipment and lift operations in Alpine Meadows and Park City—the two areas owned by the holding company AMOT, Inc. since 1971 and 1975, respectively. During the 1992–93 season, in spite of operations severely curtailed by heavy storms and closed roads, revenues reached a record high, partly due to the area staying open until the end of June—the longest season in the area's history.

Squaw Valley's lift and trail accidents in the 1970s and environmental violations in the 1980s generated enough bad publicity that many of Squaw's "faithful" went back to Sugar Bowl, traveled out of the area or went next door to Alpine Meadows.

Cushing was well aware of his resort's reputation for ill-mannered and unhelpful personnel and apologized, promising "Snow Hostesses": "Seven beautiful girls…will be available for a chit-chat, know where the best skiing is, pass out maps, and generally be ready to be of service in any way they can (up to a point)." Still counting on his Snow Hostesses to dispel Squaw's unfriendly image, he wrote in his 1977 letter:

> *With these beautiful girls in attendance, few of you had the temerity to suggest that Squaw Valley USA was still cold and unfriendly. In fact, there was only one reported case of inadequate response to our girls from a male heterosexual. One chap failed to get any message [massage?] at all and went to see his doctor, who found him to be numb from the knees up. So shook-up was this unfortunate man by his doctor's diagnosis that he went to pieces, and when last heard from, was seen skiing at Sugar Bowl—poor fellow. Beautiful Snow Hostesses will from now on be a permanent Squaw Valley USA feature. Watch out!*

Later that summer, Cushing sent another letter listing improvements in lifts and facilities, adding, "Unfriendly atmosphere? Forget it! For years we tried everything we could think of to reverse our reputation for being churlish, and with some degree of success. Then we hit it with our Snow-Hostesses—wow! Nothing speeds up the hospitality process like a spectacular girl."

Meanwhile, Alpine Meadows lift operators greeted skiers and lifted small children into the chairs. Managers, ski instructors and employees knew the names of local families, ski team members and frequent visitors. They enjoyed their company, often socializing with them after skiing.

Nick Badami and Werner Schuster, now vice president and marketing director, both agreed that the quantity, length or capacity of ski lifts did not determine the best possible ski experience. Equally important were well-groomed slopes, good food, clean and comfortable day facilities and ease of getting from car to slope to lodge to lifts. In Robert Frolich's book *Mountain Dreamers*, he quotes Badami as saying, "All this increased lift capacity and how many people you can jam into a resort has to be monitored."

Given the facts that U.S. Forest Service permits issued in the 1950s discouraged commercial development on land they leased to ski areas and that AMOT, Inc. never had the financial resources (or the desire) to invest in a base village, Alpine remained one of the few resorts in the world that had no base facilities other than a ski shop, a cafeteria and a slopeside restaurant. With Park City operating as a year-round destination resort, AMOT, Inc. could afford to let Alpine continue as a day ski area.

Schuster's personal love of the sport and his natural inclination to analyze inspired marketing plans to bring skiers to Alpine. His idea of a "Ski Week" enticed skiers from out of the area to stay for a week in a local hotel and ski all week with the same instructor. That modest program grew to a national and international bid to "Ski Lake Tahoe," a marketing program with deals and packages at six resorts around the lake. To lure Bay Area skiers, he organized races and special events for schools and ski clubs. All these efforts kept the lifts humming and the slopes alive with contented skiers into the mid-nineties.

Badami sold AMOT, Inc. to Powdr Corporation in May 1994. He and Avis moved back to Park City, where their grandson was growing up. As chairman of the board of Powdr Corp., Badami guided John Cumming and his brother in growing their company to one of the largest ski resort operators in the country, acquiring nearby ski areas Boreal Ridge and Soda Springs in 1995 and more ski areas across the country in future years.

As Alpine shifted from a public company whose board of directors and shareholders had known and loved their ski area for over thirty years to a

private corporation whose interest would be more focused on profit margins than on community relations, certain changes (aka "restructuring") were inevitable. After rehiring some key employees, many old friends and familiar faces disappeared—some voluntarily. Whether it was a cost-cutting program or a different management approach, Alpine aficionados began to notice lax lift operators, lousy food and a decline in the friendliness factor. Werner Schuster, then vice-president in charge of business development for Powdr Corp., retired (early) in 1999.

The Lake Tahoe Ski Club (competition oriented with mostly local membership) and Alpine Meadows Ski Club (socially oriented with mostly Bay Area membership) had combined their activities in 1991 to form the Alpine Meadows/Lake Tahoe Ski Education Foundation, a nonprofit organization "dedicated to promoting and supporting the continuing development of young skiers through a variety of ski competition programs managed by Alpine Meadows Ski Corporation." Bay Area and local children joined the popular Adventure Mice program, and freestyle was introduced as a new ski team option. With coaches now employed by the ski area, the foundation raised funds to support scholarships for young competitors.

Management believed that interest in freestyle skiing would soon surpass interest in Alpine competition—a belief not shared by Lake Tahoe Ski Club members and coaches, although they supported it until 1998, when Alpine Meadows announced it would no longer administer the program and asked the foundation to take over ski team operations.

At that point, Auburn Ski Club agreed to administer the foundation's activities. The race program was redesigned, with the ski team training at Boreal Ridge and the children in the Adventure Mice Programs remaining at Alpine. In 2002, the Lake Tahoe Ski Club board of directors elected not to renew their contract with the Auburn Ski Club, and after years of training first at Squaw Valley and then at Alpine, the foundation returned to their original format—a ski club whose members and competitors represented all of North Lake Tahoe and trained and competed in programs at any of its ski areas. Most of them returned to Squaw Valley, followed by their families and friends and improved relationships with the ski area where it all began.

# MIGHTY MITES TO CHAMPIONS

The legacy of Lake Tahoe Ski Club racers who grew up skiing in Squaw begins with Jimmy Heuga, whose father, Pascal ("Pete"), sold lift tickets, cut trails and worked on lifts before the 1960 Olympics. He later worked at the ice arena, retired and returned as the familiar face everyone recognized when they stepped into the tram. Coached from childhood by ski school director Emile Allais, Jimmy was a member of the United States Ski Team (USST) from 1959 to 1968. He was too young to compete in the 1960 Olympics and had to wait until the 1964 Olympics in Innsbruck, Austria, to win a bronze medal in slalom.

Almost all of Squaw's future champions began their careers as "Mighty Mites," racing for the first time on Papoose in the Easter Bunny Race. They would soon trade their stuffed animals for medals and trophies, as they skied off to bigger and scarier racecourses around the world. Eric and Sandra Poulsen, USST members and Olympians, covered the walls of their family's home (already crowded with trophies) with their own trophies, plaques, ribbons and photos from around the world. Teammate Greg Jones, 1976 U.S. downhill champ and Olympic bronze medalist in combined, went on to coach the Squaw Valley team, as have many other former Lake Tahoe and Squaw Valley ski team members, including Mark "Sully" Sullivan and Todd Kelly.

Tamara McKinney, having won eighteen World Cup trophies (including the Overall Gold Medal) and for years the world's top female racer, still lives and skis in Squaw, as do Olympians Bill Hudson, Marco Sullivan and Julia Mancuso. Travis Ganong, an upcoming USST member, lives in Alpine Meadows.

Local coaches from Osvaldo Ancinas in the 1960s and '70s to Tom Kelly, Hans Standteiner and Ernst Hager all contributed to the development of Squaw's impressive roster of USST members and Olympians. Freestyle skiers Johnny Mosely and Shannon Bahrke add a new dimension.

# SNURFING TO SQUALLYWOOD

It all began in 1965 with "snurfing." Doing what dads have done for centuries, Sherman Poppen fabricated a toy for his daughter to play on in the snow. He nailed two skis together with a crosspiece to stand on, attached a rope for her to hang on to and sent her out to ride her "Snurfer" down the snow-

covered sand dune near their home in Muskegon, Michigan. Soon, every kid in the neighborhood wanted a Snurfer. Poppen licensed his invention to the Brunswick Corporation, a local sporting goods company, and by 1966, they had sold half a million Snurfers.

By 1970, Snurfer competitions, held on the slopes of Michigan ski resorts, attracted the attention of surfers and skateboarders—all searching for a way to transfer their favorite sport onto a new surface: snow.

Tom Sims, who had invented his version of a Snurfer in his eighth grade shop class in New Jersey, came to Michigan to compete, as did Jake Burton, a veteran Vermont Snurfer at age fourteen. Dimitrije Milovich, an avid surfer, took stand-up tray riding on the frozen slopes near Cornell University to a new level in 1972 when he left college to develop his "Winterstick" with Wayne Stoveken on the steep and deep slopes of Utah.

After the first World Snurfing Championships in 1979 at Pando Winter Sports Park in Michigan, Sims, Burton and Milovich were joined by others in designing and developing snowboards, bindings, boots and other related gear. The fashion statement would soon follow. When an enthusiastic bunch of young guys in sloppy jeans and oversized T-shirts showed up at the annual SnowSports Industries America (SIA) show in Las Vegas to sell their fat, wide boards with wild graphics, ski retailers had to decide whether to embrace or ignore them. Ski areas, fearful of the image portrayed by these baggy-pantsed, grunge-looking, pot-smoking, foul-mouthed, anti-everything teenagers, barred them from their slopes, further fueling their resentment of a ski population they perceived as old-fashioned and elitist.

In 1985, only 7 percent of ski areas in the United States and Europe allowed snowboarding, so it was perhaps indicative of Squaw Valley's radical reputation to open its wide bowls and steep chutes to snowboarders in 1986. When twenty feet of snow fell in the last two weeks of March 1987, deep powder routes were discovered on Squaw's gnarliest slopes, and the word was out. Photographers and filmmakers found the perfect setting, with boarders flying off cliffs into blue skies with big blue Lake Tahoe in the background.

Alpine Meadows, catering to the tastes of its more conservative stockholders, remained snowboard free for ten more years until the spring of 1997, when the National Snowboard Championships were held at Boreal Ridge (owned by Powdr Corp., which also owned Alpine Meadows). With one of the events taking place at Alpine, management had to ask itself: how could a "family area" separate snowboarding children from their skiing parents or—even worse—send them next door to Squaw? Ski industry

Big air off the Palisade above Siberia Bowl, Squaw Valley. *Photograph by Hank de Vre.*

records show a notable increase in skiers heading to Northstar, where they could ski and board, while Alpine's growth remained flat.

Throughout the 1980s and 1990s, snowboarders and extreme skiers climbed the high ridges and cornices above Squaw Valley and, looking down, plotted their line through a rockbound chute. Meanwhile, hundreds of ordinary skiers gathered below, looking up, wondering and waiting when that small figure on the horizon would drop into the gully, committing himself to a near free-fall down a sixty-degree grade and inventing his route as snow conditions and his ability to change directions would allow. Careening into a wall of granite, a tree or a rock were the consequences of losing your line. Cartwheeling downhill in a snowball of swirling snow, skis and poles was the result of a miscalculated jump. "Oohs" and "ahhs" proclaimed a successful jump from a cornice or rocky outcropping to solid snow as the skier or boarder finished his leap of faith upright, carving a sweeping turn above an admiring crowd.

Beginning in the late 1960s, when Rick Sylvester first pointed his skis down the chutes and chimneys of the Palisades above Siberia Bowl, and into the 1970s, when Bobby Burns executed an eighty-foot flip off that lofty cornice, to Craig Beck's many leaps from many rocks and Steve McKinney's schuss down "the Tube," extreme skiing has been a part of Squaw Valley culture.

Johnny Moseley, freestyle Olympic gold medalist, crosses over Squaw. *Courtesy of Elevated Images Photography.*

Those early radical lines and leaps inspired future rock stars like Scott Schmidt, Shane McConkey, Dave Hatchett, Robb Gaffney, Ingrid Backstrom and many more—all of whom expanded extreme skiing to big-mountain skiing and snowboarding. Although filmmakers and photographers followed their heroes to exotic locations in Alaska, Canada, Europe and South America, they ultimately returned to the challenging terrain of Squaw— their home ground that gave the valley its nickname: Squallywood.

## REILY'S LAST STAND AT TWIN PEAKS

John Reily's master plan for Twin Peaks Estates, a residential resort community in Ward Valley linked to Alpine Meadows and presented to Placer County Planning Commissioners in 1969, was funded by General American Development Corp. in Sacramento, Alpine Meadows of Tahoe, Inc. (who owned the backside of Ward Peak) and Southern Pacific Land Company (who intended to lease land for the lodge). For the ten years after that hearing, Reily commuted back and forth to Auburn, cajoling, convincing, reasoning and arguing, that his plan was a good one for the

thousands of skiers who needed a home in the mountains. Hearings dragged on as homeowners along the proposed access road objected to thousands of cars driving through their quiet neighborhood to the ski area. Sunnyside residents, resigned to the inevitability of population growth along Lake Tahoe, attended meetings, asked questions and tried to limit development. Conservationists questioned the water supply and the environmental impact on Ward Creek's trout spawning ground. Taxpayers vehemently opposed the U.S. Forest Service trading land for a parking lot. A population growth of twelve thousand to seventeen thousand between the lake and yet another pristine mountain valley raised protests, questions and possible solutions as plans were changed, adjusted and discussed. Population density, zoning issues and road placement were all hot topics, until planners, politicians, developers, conservationists, residents and even John Reily ran out of money, energy and hope.

Reily was often seen trundling through town in his huge motor home—usually on his way to a meeting of some government agency. Over the summer of 1983, he rented space in the parking lot at Jim and Sue McCafferty's Lake of the Ski Motel in Tahoe City. Friends since the 1960s, when Reily brought prospective Alpine Meadows investors to stay at the motel, Reily now prevailed on their goodwill to occupy a large space on their property. As winter approached, friends and family pleaded with Reily to get out of the parking lot before winter as he had agreed. Eventually, Reily returned to his space in the parking lot at Alpine Meadows, where the year before a devastating avalanche had swept right by him. Content watching the life of the ski area he founded unfold around him, he enjoyed visits from his niece Cheryl Llyod, a student at UC Davis who loved her "Uncle Mac" for his "profound energy" and for the secrets they shared about her boyfriends and his women over whiskey in the camper. "I was eighteen," she said in an interview in Reno, where she now lives. "I was rebelling against my parents, and Uncle Mac was a great listener. He had a bigger vision than most of his family or their contemporaries."

At last, in the summer of 1984, Reily's daughter Joan prevailed upon her seventy-seven-year-old father to move his camper to a campground near her home in Newport Beach. John McClintic Reily died December 16, 1984, in a hospital after taking water into his lungs in a Jacuzzi at the campground.

In July 1987, the Lake Tahoe Conservancy acquired 402 acres on the backside of the Alpine Meadows Ski Area and 437 acres that included Twin Peaks from the Southern Pacific Land Company.

# WENDT AND THE 150-ACRE PARKING LOT

Nancy Wendt came to Squaw Valley in 1985 to consult for a New York law firm on land issues at the base of the ski area. An experienced skier who appreciated the varied terrain and scenic beauty Squaw offered, she looked at the great asphalt parking lot between the mountain and the meadow and wondered if the area's future might lie there. Two years later, "Wendt" (as Cushing affectionately caller her) returned to Squaw Valley as Cushing's wife, best friend, confidante and legal advisor.

In the 2008 edition of the *Harvard Law Bulletin*, Andy Dappen wrote an article about the university's two alumni in which he quotes Cushing crediting his wife "as the inspiration behind the resort's latest transformation. 'We were riding up the mountain, and she commented this was a pretty good ski hill…then she asked, 'But is it the best you can do?'"

Having acquired Blyth Arena and the 150 acres surrounding it at an auction in 1982 (an event Cushing proudly describes in his May 2000 newsletter as Burkhart's "marvelous coup, whereby he bought Blyth arena at a public auction by bidding against himself"), Cushing had ample room to build base facilities for his ski area—if he wanted to.

Ever since Cushing had visited the Alpine villages of Austria and Switzerland, he longed to establish a mid-mountain village of his own. Acknowledging a need to attract visitors year-round, he announced in his 1976 newsletter, "Squaw Valley el. 8,200—Brand New! The new multi-million dollar resort, when completed, will be independent and self-sufficient with its own hotels, bars, restaurants, shops—the works!" In his next letter, Cushing posed a question asked by a former mountaineer of note: "Why two ski areas? Because they are there."

Alex Cushing and his mountain.
*Photograph by Hank de Vre.*

The location of the tram terminal provided the perfect setting for Cushing's "High Camp—the Eighth Wonder of the World," as he often referred to it. Alexander's, a sit-down, white-tablecloth eatery opened at High Camp in 1978.

From the mid-1980s into the 1990s, Cushing pursued his plans to include an Olympic-size skating rink, a swimming

pool, a heated swimming lagoon, six tennis courts (two of them radiant heated for winter play), a spa and a golf course. Now referred to as the Squaw Valley Bath and Tennis Club, a hotel for overnight guests would make it a destination unto itself. He called Squaw Valley's favorite architect Henrik Bull, who had designed High Camp in its present state. Bull (along with Burkhart and many others) questioned the practicality of a hotel in this location. Always in admiration of Cushing's imagination and sharing his enthusiasm for a new and adventurous project, Bull designed a three-story structure along the edge of the cliffs north of the tram building.

"Alex didn't believe in cost-benefit studies," Bull said later. "If he wanted something, he just wanted to see it happen—no matter the need or the cost."

Meanwhile, down at el. 6,200, Nancy saw the potential of a larger, more accessible village. In 1989, she and Cushing commissioned a land planner and four architects (including Bull) to submit plans for a village at the base of the ski area.

With most of what Cushing planned up and running at el. 8,200, Alex and Nancy were still studying their plans for the base area in 1994 when John Fry, noted ski writer, ski historian and then editor of *Snow Country* magazine, rode down the lift with Cushing on a cold, starry night. As Fry looked down on the slopes, which were illuminated for night skiing, he pointed out that it was a crime to have so much mountain grandeur above and nothing but a big dark parking lot below. Cushing agreed, lamenting that he had neither the cash nor the skills to produce an Alpine Village. Fry suggested they contact Intrawest and made the phone call that linked Ski Corp. and the experienced developers of Blackcolm-Whistler, Mount Tremblant and Copper Mountain. In spite of cries from the locals to "Save our Parking Lot," a final plan was adopted in December 1996, with construction optimistically planned to begin in 1998. In reality, it began in 2002.

## AN END AND A BEGINNING

By the time Alexander Cushing died in 2006 at the age of ninety-two, Squaw Valley had grown from a rebellious adolescent to a mature adult. During the last twenty years of his life, Cushing was often seen walking arm in arm with Nancy through the parking lot and the village, greeting friends and strangers. His annual letters almost always closed with words of appreciation for his staff and supporters—"the Squaw Valley Family."

Lawsuits were over. Lifts were modern, fast, safe and well maintained. The new Resort at Squaw Creek, with its lift connecting to the area on top of Red Dog, made "ski-in, ski-out" a reality. The bar and restaurant at Plump Jack's boutique hotel was as popular with locals as it was with visitors. Ski area employees wore black parkas with a diagonal red stripe emblazoned with the message, "We Care." Kleenex boxes at lift loading stations were a subtler message of Squaw's evolving attitude.

Ernst Hager, U.S. Ski Team coach from 1991 to 1996 and a Squaw Valley resident for the past thirty years, became general manager in 2002. His wife, Linda, had run the Children's World long enough to know every kid who skied at Squaw over the last twenty years. Affable and approachable, Ernst was seldom in an office, preferring to be out and about meeting the public. He made mountain grooming a high priority, sending the area's fleet of grooming machines off in all directions late at night, where they worked until dawn, laying out a corduroy carpet on every slope they touched.

When Nancy Cushing became chairman and CEO of Squaw Valley Ski Corp. in 2006, large corporations began to eye one of the last privately owned major ski resorts. When Ski Corp., under her leadership, purchased the Intrawest Village, rumors had it that Squaw was positioning to sell. "Not so," claimed Cushing.

A year later, JMA Ventures, a publically traded real estate investment company that already owned Homewood Ski Area on Lake Tahoe, bought Alpine Meadows from Powdr Corp. Jim Kercher returned from Beaver Creek to manage the area where he was once a ski instructor. He brought back many of Alpine's former employees and with them the care and dedication they still had for the area they had grown up with. Pride of ownership—even if you didn't own it—had always been an Alpine ethic. JMA infused new capital into lodge and mountain improvements, and many of Alpine's old guard returned.

Nick Badami died in Park City in 2008, just two years before KSL, a private equity firm, bought Squaw Valley. One year after that, KSL silenced the rumormongers by acquiring Alpine Meadows.

New voices now ask old questions: What high mountain run will bring skiers from Squaw into Alpine? What lift will take them back to Squaw?

And old voices ask new questions: Will the ski experience as defined by Poulsen, Reily, Cushing and Badami be forever changed from a way of life to a "highly developed form of industrial tourism," as Hal Clifford portends in his book *The Downhill Slide?*

Poulsen fence at Squaw Valley Meadow. *Photograph by Tom Lippert.*

Chair One (Summit) at Alpine with Wolverine Bowl in the background. *Photograph by Donald E. Wolter.*

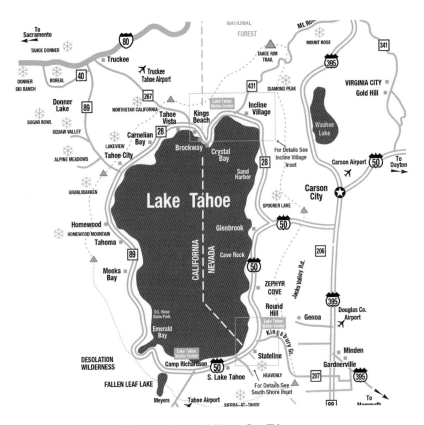

Lake Tahoe, California/Nevada. *Courtesy of DiscoverRenoTahoe.com.*

As long as Pacific storms sweep across the Sierra Nevada and cover the peaks that rise above both valleys, skiers will find their way through glades of fir trees, carve turns down an open bowl or climb out on a cornice to look at Lake Tahoe. Nothing can take that away.

# Epilogue

November 2024 marks the seventy-fifth anniversary of Wayne Poulsen's dream and Alex Cushing's reality—a ski area that developed from one lift and one lodge in 1949 to an Olympic site in 1960 to one of the major ski resorts in the world today. When KSL Capital Partners bought Squaw Valley in 2010 and merged with Alpine in 2012, the combined areas became the largest ski resort in California and second largest in the United States. Today, Palisades Tahoe (and eighteen other ski destinations and growing) is owned by Alterra Mountain Company.

In 2021, the ski area, known as Squaw Valley/Alpine Meadows, changed its name to Palisades Tahoe. The decision to rename the resort was made after extensive research into the usage of the word *squaw* and after discussions with the local Washoe Tribe, who affirmed that it is a racist and sexist slur against Indigenous women. For more information, you can visit palisadestahoe.com.

In spite of Hal Clifford's fear that large corporations will transform ski areas and mountain communities into "a form of industrial tourism," the two valleys have maintained their distinctive personalities. Alpine, with no commercial development in the community or at the resort, has the same laid-back, intimate experience it has enjoyed since the first run on "Chair One" in December 1961, and locals continue to call their valley and favorite ski area "Alpine." Because "Olympic Valley" was the name given to the U.S. Post Office in 1960, residents refer to their valley as Olympic Valley, whereas the ski resort is now called Palisades.

Meanwhile, the joy of skiing, the challenge of terrain and the eternal quest for the perfect turn in these two valleys have not lost their allure and probably never will. The "skiing experience," however, has changed in ways that Poulsen, Cushing and John Reily could never have imagined: longer, faster, better lifts (and lift-lines); better grooming; better equipment; snowmaking; and ever more imaginative ways and equipment on which to ascend or descend the mountains.

One thing Poulsen, Reily and Cushing did imagine, however, was that someday the two areas would be linked by a trail, an aerial tram or a combination of chair lifts. That finally happened in December 2022, when the Base to Base gondola began transporting skiers from the base at KT-22 to the base at Alpine Meadows.

In spite of the changes over the past seventy-five years, skiing is still "a way of life" for a new generation of skiers, snowboarders and backcountry explorers.

"I seldom ski on groomed slopes anymore," is a statement heard in locker rooms and parking lots of both areas, where a few hardy skiers, searching for the wonder of the wilderness, load their packs with shovels, climbing skins, avalanche probes and gear to survive in the acres of untouched terrain beyond the confines of both ski areas. The same primal need to venture into unknown territory that enticed Wayne Poulsen to skin up and ski down these mountains in 1939 hasn't changed. The equipment is improved, but the lure of adventure and the exhilaration of discovery live on.

# Bibliography

Clifford, Hal. *Downhill Slide*. San Francisco: Sierra Club Books, 2002.

Fiedler, Jane. *A History of Squaw Valley*. Philadelphia: Macrae-Smith, 1977.

Frohlich, Robert. *Mountain Dreamers*. Truckee, CA: Coldstream Press, 1997.

Fry, John. *The Story of Modern Skiing*. Lebanon, NH: University Press of New England, 2006.

Gaffney, Robb, MD. *Squallywood*. Tahoe City, CA: Westbridge Publishing, 2006.

McLaughlin, Mark. *Longboards to Olympics*. Carnelian Bay, CA: Micmac Publishing, 2010.

————. *Skiing at Lake Tahoe*. Charleston, SC: Arcadia Publishing, 2011.

Micoleau, Tyler. *The Story of Squaw Valley*. New York: A.S. Barnes and Company, 1953.

Scott, Edward. *Squaw Valley*. Crystal Bay, NV: Sierra-Tahoe Publishing Co., 1960.

Squaw Valley Ski Corporation. *Squaw Valley USA: Celebrating Our Olympic Legacy*. Squaw Valley Ski Corporation, 2010.

————. *Squaw Valley USA: The First Fifty Years*. Squaw Valley Ski Corporation, 2009.

Woodlief, Jennifer. *Wall of White*. New York: Atria Paperback, 2010.

# Index

# ABOUT THE AUTHOR

Eddy Starr Ancinas, descendant of a California ski and mountaineering family, first skied at Badger Pass in Yosemite in the 1940s before following many California skiers to Sugar Bowl and on to Squaw Valley when it opened in 1948. She was a guide for the International Olympic Committee in Squaw Valley at the 1960 Olympics, where she met her husband, a member of the Argentine Olympic Team. They raised their family in Alpine Meadows, where he was a ski coach for the Lake Tahoe Ski Club. During the '70s and '80s, they owned and operated ski shops (Casa Andina) in both Alpine and Squaw. Eddy has been a contributor to *Skiing Heritage* magazine and has published an article on the 1960 Olympics for *The Atlantic*. Currently, she is a board member of the Squaw Valley Ski Museum Foundation, whose goal is to build a museum at the entrance to Squaw Valley. She and her husband live between the two valleys.

*Visit us at*
www.historypress.net